D1372671

WATERCOLORS
LANDSCAPE

Brian and Ursula Bagnall • Astrid Hille

WALTER FOSTER PUBLISHING, INC.
Laguna Hills, California

Published by Walter Foster Publishing, Inc.,
23062 La Cadena Drive, Laguna Hills, CA 92653.
All rights reserved.
English translation copyright © 1994 Joshua Morris
Publishing, Inc., 355 Riverside Avenue, Westport, CT 06880.
Produced by Joshua Morris Publishing, Inc.
© 1993 by Ravensburger Buchverlag Otto Maier GmbH.
Original German title: *Landschaft bei Wind und Wetter.*
Cover painting by Laurie Sartin.
Printed in Hong Kong.

ISBN: 1-56010-180-6
10 9 8 7 6 5 4 3 2

Contents

About This Book

In a time like the present when everything moves quickly, it is no surprise that watercolor has become one of the most popular media of the hobby painter. With very little expense or effort, it is possible to paint almost anywhere—for example, on trips—and to produce expressive paintings in a relatively short time. Behind this ease, however, lurks a problem. How can you control the elements that make painting in watercolor so attractive in the first place—namely, the spontaneous textures, the expressive paint-runs, and the pure, transparent colors? How can you incorporate them into a landscape painting to give the impression of a thunderstorm, or heat, or water, or cornfields?

The answers to questions like these are here in the following pages. You'll learn how to transfer what you see in nature onto paper, with experienced artists showing you what's important and what can be left out. You'll also see that even paintings you think are ruined can contain some interesting, new ideas. Moreover, the many illustrations and suggestions are sure to inspire your own experiments.

Using step-by-step examples, you'll be able to reproduce exactly what the different artists show you. You'll discover the individual ways they approach landscape painting and what is important to them. Some artists paint outdoors; others—such as Karlheinz Gross—take a Polaroid photo or a sketch home, where they work out their paintings. The most important consideration, however, is that you enjoy exercising your creativity. That's why a few experiments are provided to give you some ideas for continuing on your own.

Because every artist develops a personal style, it is important not to be limited by studying only one way of painting. Therefore, every step-by-step example has been contributed by a different painter so you can become familiar with various approaches to watercolor. Then you can decide for yourself which one suits you.

Have fun!

Brian Bagnall

Brian Bagnall is the art director of the Artist's Workshop series. Through his experiences as a professor in England, Holland, and Germany, he has learned what students enjoy and what they find difficult.

Brian Bagnall was born in 1943 in Wakefield, England. After studying painting and etching, he moved to Amsterdam, where, in addition to teaching, he worked for publishing houses and advertising agencies. He was also active for many years as a professor in Darmstadt, Germany.

Since 1970, he has lived in Munich, where he and his wife, Ursula, opened Bagnall Studios. His work has been exhibited throughout the world.

Ursula Bagnall

Ursula Bagnall is responsible for the text and layout of the Artist's Workshop series. She organizes the artists' illustrations and explanations.

Ursula Bagnall was born in 1945 near Munich, where she completed her training in graphic design at the Akademie für Graphisches Gewerbe. Afterward, she worked with Otl Aicher on projects for the 1972 Olympic Games and later took a teaching position at an American school in Amsterdam. Since 1973, she has worked with her husband, Brian, as a graphic artist and author. They have written many books together, among them several art instruction books for children and adults.

Astrid Hille

Astrid Hille is the editor of the Artist's Workshop series and works closely with Ursula and Brian Bagnall.

Hille was born in 1955 in Hamburg, where she studied illustration and painting at the Fachhochschule für Kunst und Gestaltung. Afterward, she worked as an illustrator and painter as well as an art teacher in adult education. She completed a second degree in multimedia education and has been a proofreader of art books and children's books since 1985.

Laurie Sartin

Laurie Sartin shows how to paint wind and weather.

Born in 1949 in Sussex, England, Sartin was active for many years as an illustrator of archaeological publications; painting was a leisure-time activity. Through his participation in medieval-theme festivals, he met his wife, a German, and in 1984 they moved to Landshut, Germany. He is the father of two children.

In 1987, Sartin began illustrating children's books and also pursued painting, drawing, and caricaturing. He is an established free-lance artist and has taken part in numerous group exhibitions in Landshut and Munich.

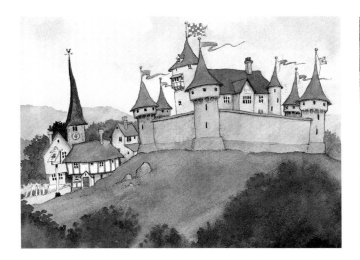

Eberhard Lorenz

Eberhard Lorenz shows how to paint reflections in the water.

Lorenz was born in the German state of Saxony in 1936. From 1953 to 1956, he studied art in Leipzig, then worked as a stage designer for WDR, the West German broadcasting system, in Cologne. In 1963, he went to Munich and became a stage designer for the Theater am Gärtnerplatz. He switched to free-lance painting in 1967, however, and went to Amsterdam to teach painting and graphic design. He returned to Munich in 1971. Lorenz works as a free-lance painter in Oberschleissheim and has made quite a name for himself in single and group exhibitions all over Europe.

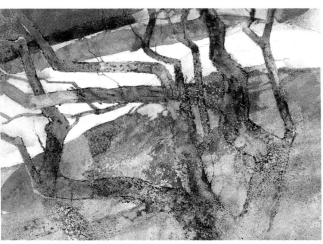

Beate Weber-von Witzleben

Beate Weber-von Witzleben shows how to paint delicate, snow-covered landscapes.

Weber-von Witzleben was born in 1953 and grew up near Lake Constance. She was involved with painting, poetry, and theater before she began her studies in Freiburg in 1973. After completing her studies, traveling, and exhibiting, she began an intensive study of East Asian painting. Since 1979, she has taught painting, drawing, and art history, and she has written a book on watercolor painting. She has also had many exhibitions, including one in Tokyo.

Karlheinz Gross

Karlheinz Gross leads you step-by-step to southern Europe in his paintings.

Gross, born in 1943 in Harz, Germany, studied at the Werkkunstschule A.L. Merz, in Stuttgart. He later took courses in commercial art and illustration under Robert Förch at the Gutenbergschule, also in Stuttgart. In 1966, he opened his own studio in Bietigheim-Bissingen, Germany, and has since worked as a free-lance graphic artist and painter. He also teaches watercolor painting. Since 1971, his work has appeared in many single exhibitions.

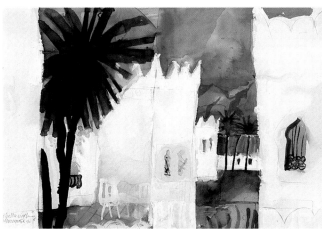

Watercolor Painting—Yesterday and Today

Watercolor is not, as one might assume, a painting medium created in our modern, fast-paced age. Actually, the opposite is true. Watercolor is one of the oldest media known. Early people simply used what they had, mainly materials that are easily found in nature. Clay, soil, and minerals, for example, were made into pigments, mixed with water, and used as paint. Not until later did artists begin to work with other materials, such as egg and gypsum, and only after extensive experimentation did they add oil. Strictly

Not until the eighteenth century did watercolor painting gain significance. English artists such as John Sell Cotman (1782-1842), J.M.W. Turner (1775-1851), and John Constable (1776-1837) developed this medium to a higher degree than ever previously achieved. At first, watercolor was used to paint landscapes. The transparency, lightness, and flowing quality of the paints seemed to be tailor-made for nature scenes. Later, the Impressionists and the Expressionists—for example, Emil Nolde

The ease of painting in watercolor is exactly what makes it so difficult. You have to learn to handle accidents—or to make them happen "intentionally." You have to learn to use the transparency of the paints and to plan the way the colors will run together. Moreover, you also have to learn that you can seldom fix a watercolor painting. It is important to experiment a lot, to mix different colors, and to try out different kinds of paper. Always remember: A sheet of paper is the only

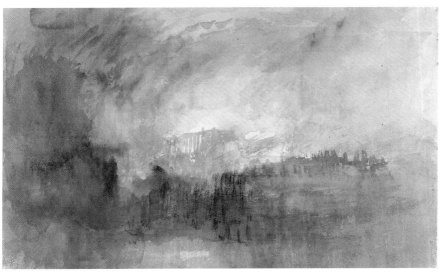

J.M.W. Turner, *The Burning of the Houses of Parliament*

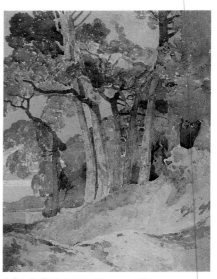

John Sell Cotman, *Trees at Harrow*

speaking, the early frescoes are a form of watercolor painting.

Watercolor paintings, as they are known today, did not appear until the beginning of the fifteenth century. These pictures, however, were not pure watercolor paintings but rather were drawings or sketches colored in with water-based paints.

Albrecht Dürer (1471-1528) painted the first genuine watercolor paintings—that is, the first works done exclusively in watercolor. To be sure, oil paintings enjoyed greater prestige at that time; watercolor was used mainly for sketches and to determine the color scheme for the final oil painting. For many years after Dürer, nobody continued his pioneering work in watercolor. Into the seventeenth century, watercolors were used simply to add tint to drawings and prints.

(1867-1956), Paul Klee (1879-1940), and Lyonel Feininger (1871-1956)—also began to work in watercolor. These painters did not limit themselves to landscapes but used the medium for portraits, still lifes, and architecture as well.

Today, watercolor owes its large appeal to the manageability of the medium and the ease with which quick, effective results can be achieved. The paper and paints are easy to carry, and water can be found almost anywhere. Of course, landscape remains one of the most popular motifs. You can capture vacation memories, impressions of the countryside, or moods created by the weather. Because watercolor is comparatively easy to use, many people think it is also the simplest medium in which to work. This, however, is not true.

thing you have to lose in the process of experimenting and learning.

Watercolor painting does have one characteristic in common with other popular art media: it is fun to explore all the different possibilities.

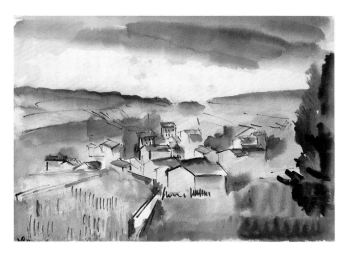

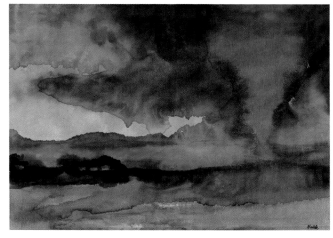

[above left]
Maurice de Vlaminck, *Landscape*

[above right]
Emil Nolde, *Flood*

[left]
Paul Cézanne, *Château at Médan*

[below]
John Middleton, *Alby, Norfolk*

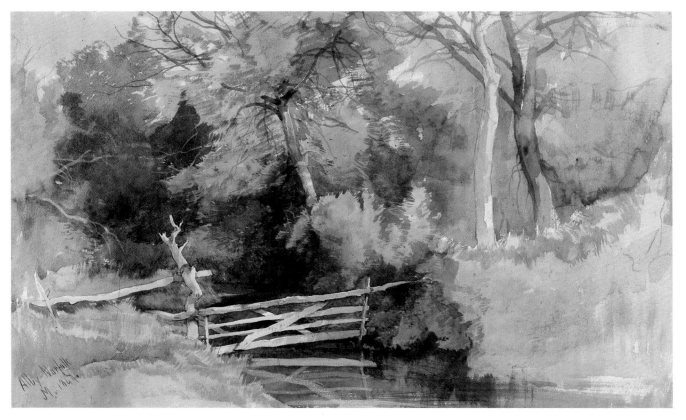

Choosing Materials

The right supplies are absolutely necessary to achieve good results in watercolor painting. It is best to buy fewer supplies but to make sure they are of high quality.

Selecting Brushes

It is especially important to buy high-quality brushes. At first, three brushes will be enough: one thick brush and two thinner ones. Choose genuine sable brushes (sometimes called red sable or kolinsky sable); a number 3, a number 6, and a number 10 are recommended. You can also buy several inexpensive brushes to paint backgrounds or to work out rough areas of your paintings.

When you're not using your brushes, roll them up in a bamboo mat (see photo, in front of the vase). The rolled mat protects them from dust, keeps the delicate tips from becoming bent, and enables you to carry the brushes easily. If you don't plan to work with your brushes for an extended period, store them in a drawer or some other closed container. Otherwise, dust can build up in the tips and cause them to fray. You should always clean your brushes thoroughly after each use. Shake them (never squeeze them), and allow them to air dry.

Selecting Paints

You can use paints in tubes or in pans; both types are available individually or in sets. The advantage of buying a set is that you can store your brushes inside the box and use the lid as a palette; the disadvantage is that sets often come with colors that do not necessarily mix well. If you decide in favor of sets, be sure they contain the most important colors: chrome yellow, cadmium yellow light, cadmium red light, alizarin crimson, cerulean blue, and ultramarine blue (see pages 10 and 11 for more information about mixing colors).

You will need to experiment to find out whether you're more comfortable with paints in tubes or in pans. The paints that come in tubes are more brilliant, but they're also more difficult to use. If you accidentally squeeze too much paint out of the tube, however, there is no need to worry. When the paint dries, you can simply add water to it and continue using it.

Water must be added to the paints that come in pans every time the paints are used. It is important to remember to leave space between the individual pans in the paint box; otherwise, the paints can run together.

Odds and Ends

Once you have assembled your brushes and paints, you need to gather a few additional supplies: a water container, a towel or tissue to blot up excess

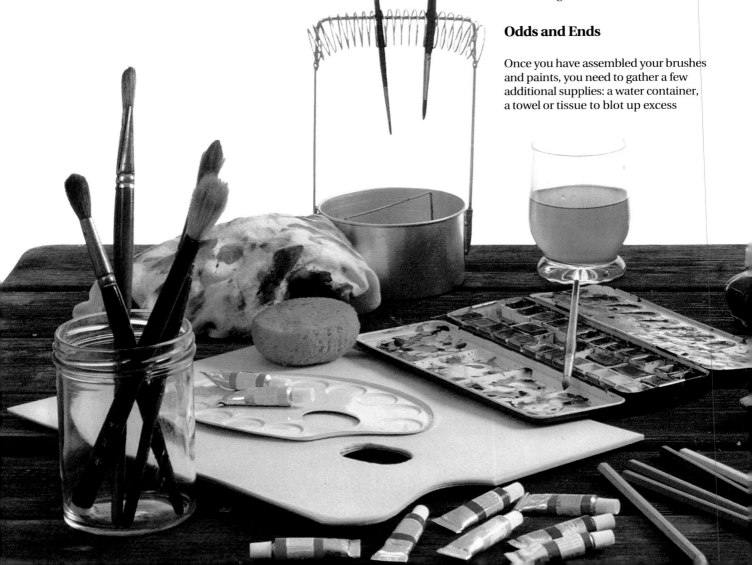

paint, and a small sponge. You can use the lid of the paint box or a small metal palette as a surface for mixing paint. There are also palettes made of individual sheets of water-repellent paper, which you can tear off when you've finished with them (in the photograph below, the paper sheets are under the plastic palette). A brush holder like the one pictured is also practical so that excess paint and water can drip off the brushes.

You need a soft pencil for preliminary sketches, and, for retaining white areas, you need liquid frisket or a candle (the use of liquid frisket is explained on page 13). The following items may also be useful: brown, gummed paper tape and a knife for stretching the paper, and inks and colored pencils for experimenting.

Selecting Paper

The texture of the paper is very important in watercolor painting because the paints react differently on different kinds of paper. You can see this effect clearly in the example at the right. On the smooth paper, the brush distributes the paint evenly, but the brush stroke doesn't completely cover the rough paper—white areas remain.

See for yourself which kind of paper you like best. The simplest thing to do is to get some samples from an art supply store and experiment with different paper textures. You can buy watercolor paper in blocks or in individual sheets.

Because the paper buckles when it gets wet, you have to stretch the individual sheets on a board and tape down the edges. The blocks of paper are bound along all four edges to prevent the paper from curling up as you paint. Many artists prefer the individual sheets because the selection is larger. The blocks, however, are more practical for carrying.

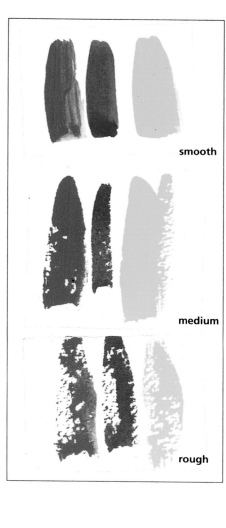

smooth

medium

rough

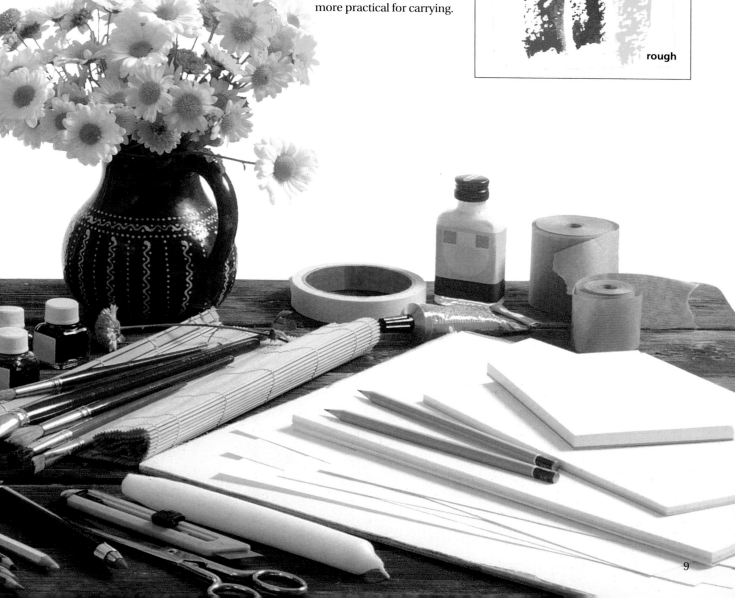

9

Mixing the Paints

One of the most appealing features of watercolor painting is the ease of blending the paints. In addition to the nuances that occur on the paper when the paints run together, you can mix interesting colors that are not available among the paints found in stores.

You'll be amazed at the array of colors you can produce with just a few paints. Naturally, the stores' huge selections of colors arranged in beautiful displays are tempting. If you mix the wrong ones, however, you'll get only muddy browns and grays. It is especially risky to mix colors that have already been mixed, and mixtures are exactly what many of these store-bought colors are. So, in the case of the colors you buy, less is more.

The basic palette—chrome yellow, cadmium yellow light, cadmium red light, alizarin crimson, cerulean blue, and ultramarine blue—offers a surprising range of possibilities.

Basic Palette

| chrome yellow | cadmium yellow light | cadmium red light | alizarin crimson | cerulean blue | ultramarine blue |

Expanded Palette

| cadmium orange deep | yellow ochre | burnt umber | Hooker's green light | violet | chromium oxide green |

If you want to expand this basic palette, the colors above are recommended. They can be combined with excellent results, and they'll give you a multitude of hues. For practice, mix these colors in different combinations, just two at first, then three. Mixing more than three colors usually results in unattractive hues. The only way to gain confidence in dealing with color is to practice and experiment.

Every artist develops preferences and dislikes. Eberhard Lorenz, for example, must have his Prussian blue, and Laurie Sartin always brightens a gloomy painting with Naples yellow. If you don't want to mix your grays, Payne's gray is suitable for almost anything without appearing or becoming "dirty."

From left to right: Naples yellow, Payne's gray, and Prussian blue

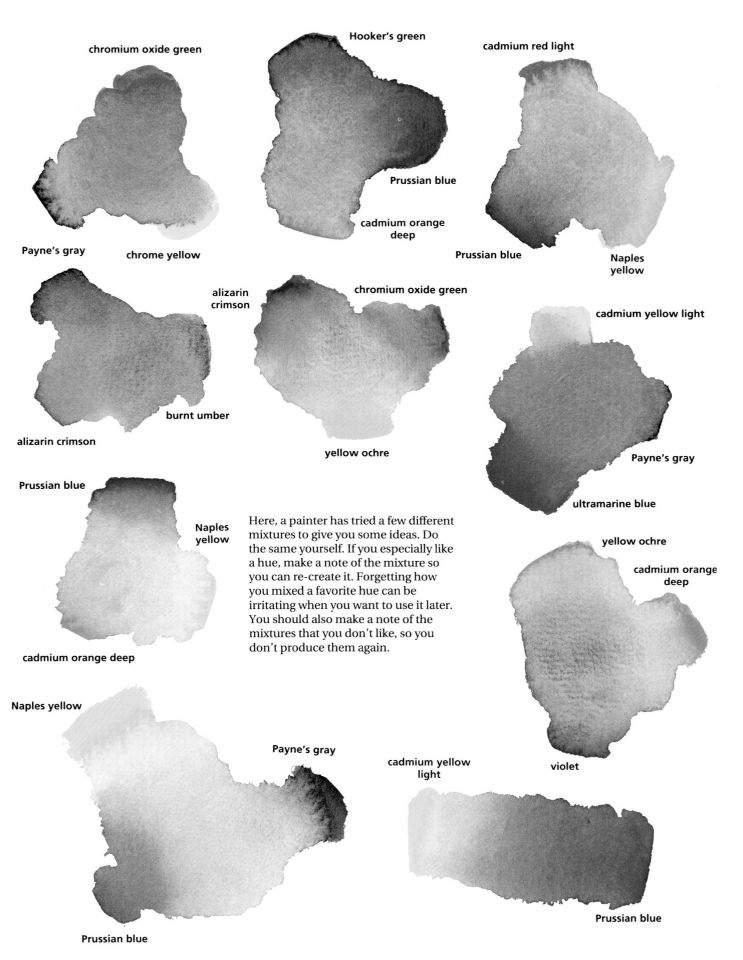

chromium oxide green

Hooker's green

cadmium red light

Prussian blue

cadmium orange deep

Payne's gray

chrome yellow

Prussian blue

Naples yellow

alizarin crimson

chromium oxide green

cadmium yellow light

burnt umber

alizarin crimson

yellow ochre

Payne's gray

ultramarine blue

Prussian blue

Naples yellow

yellow ochre

cadmium orange deep

Here, a painter has tried a few different mixtures to give you some ideas. Do the same yourself. If you especially like a hue, make a note of the mixture so you can re-create it. Forgetting how you mixed a favorite hue can be irritating when you want to use it later. You should also make a note of the mixtures that you don't like, so you don't produce them again.

cadmium orange deep

violet

Naples yellow

Payne's gray

cadmium yellow light

Prussian blue

Prussian blue

Watercolor Techniques

The most appealing aspects of watercolor are its spontaneity, the transparency and brilliance of the colors, and the coincidences that can be incorporated into the painting. The best way to become familiar with this medium is to experiment. There are, however, a few basic techniques you should be familiar with.

Working Wet-in-Wet

Wet-in-wet is a technique of working with fresh paint on a wet surface, producing soft blends and delicate contours. To practice this technique, first wet the paper with a sponge or cloth. You can also use a thick brush to wet parts of the paper where you want the paints to run together. Be careful not to wet the paper too much, however, because "puddles" can form where the paints run together, and the colors will become unrecognizable.

When you apply wet paint to the wet paper, the paint runs, and if you apply other colors, they blend with the first color. The result is completely new hues. You can see the effect of working wet-in-wet in the yellow and red of the treetop to the right.

Working Wet-on-Dry

The technique of applying fresh paint to a dry surface is called wet-on-dry, which results in clear shapes. There are two ways to work wet-on-dry:

1. Apply wet paint directly to dry paper. In this way, you can achieve smooth edges (see below in the green and yellow background of the potted tree).

2. Apply wet paint to a painted area that has already dried. Of course, if you overpaint the dry area with more than one color, you can let them run into one another. You just have to be careful that the new paints do not disturb the first layer.

The wet-on-dry technique is often used to add details and highlights to a painting that is almost complete.

Glazing

Applying glazes involves using thin layers of paint so the colors underneath shimmer through. This effect is relatively easy to achieve with watercolors because the paints are so transparent, but the glazing technique can be used intentionally to create certain nuances. For example, the painter of the tree below used several layers of color in the grass beneath it. The base layer continues to shine through, giving the painting depth.

Spattering

Some artists like to intentionally spatter the paints. The drops remain on the dry areas, and they run where the surface is wet. This spattering technique can result in lively textures, which may be added to tranquil areas to create contrast.

To spatter the paint, you can simply shake the brush, but you have to be careful that you don't get paint in areas where you don't want it. You can use a sieve to produce finer spatters. Dip a small brush (a toothbrush, for example) in paint, and rub it across the sieve while holding it above the paper.

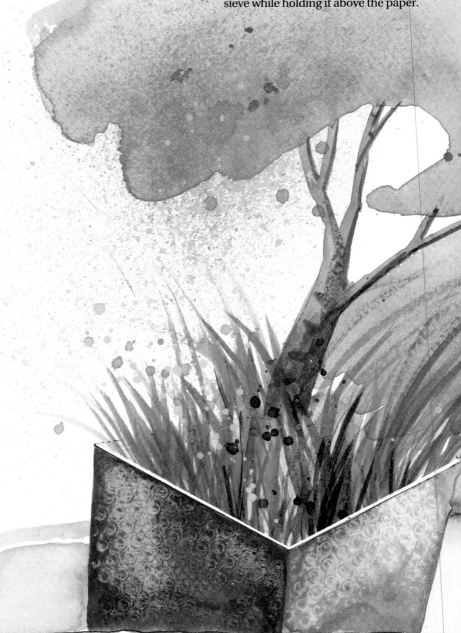

Using White in Watercolor

White is an important element for highlights. In watercolor, you have to carefully paint around the shapes you want to remain white because you cannot add it at the end of your work, as you can with other painting media.

You can also use a rubber solution, such as rubber cement or liquid frisket, to coat the areas that you want to remain white. Then simply paint over it. When the paint is dry, rub off the solution, and the surface underneath will be white.

Sometimes watercolorists use a tube of rubber cement to draw directly on the paper—a technique illustrated by the white streaks in the sky below. The pyramid was originally blocked out with frisket. The artist later rubbed the frisket off and painted the area.

Masking with Liquid Frisket

Liquid frisket is useful not only for masking off areas of white, but also for covering areas that have already been painted so you can paint over them again. When you rub the frisket off, the first color is still there.

Because watercolors don't adhere to the frisket, they form beads on it. Sometimes you can use this texture in your pictures by painting over the frisket and leaving it in place.

Laying Washes

You can use washes to paint smooth surfaces, such as a clear sky or calm water. Work from top to bottom on a wet surface. With even strokes, begin applying color in the dark areas, and as the color becomes weaker, work your way to the light areas. If the dark areas are at the bottom, as in the painting of the pyramid here, simply turn your paper upside down. Clean water is very important when you're laying in washes.

Additional Techniques

Hard edges are not easy to achieve in watercolor because the paper is often rough and the colors run easily. To make a hard edge, you can tape off areas on smooth paper and peel the tape off after the paints dry. The paper shouldn't be too soft or fibrous, however; otherwise, it will peel off with the tape. Here, the artist used tape to achieve the hard edges of the planter.

You can also lift off paint with a tissue to make interesting textures. Here, the artist worked on Canson paper, which has a woven texture. On the planter, the artist lifted off some of the partially dry paint.

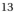

Creating Moods

The mood of a painting depends to a large extent on its colors. A brightly colored sky does not turn the viewer's thoughts to threatening thunderstorms. Even a painting of a crying face appears less sad when the cheeks are rosy.

People differentiate between two categories of color: warm and cool.

Experience conditions observers to perceive blue hues as cool, because cold, deep water and ice appear blue. Yellow and red hues, in contrast, are associated with warmth because they remind observers of fire and the sun. Of course, some colors—for example, neutral hues such as red-violet and

yellow-green—do not fit neatly into either category. In general, however, colors containing more red or yellow appear warm, while those containing more blue appear cool. These effects are especially important when you're mixing colors. You can, for example, mix a warm blue or a cool red.

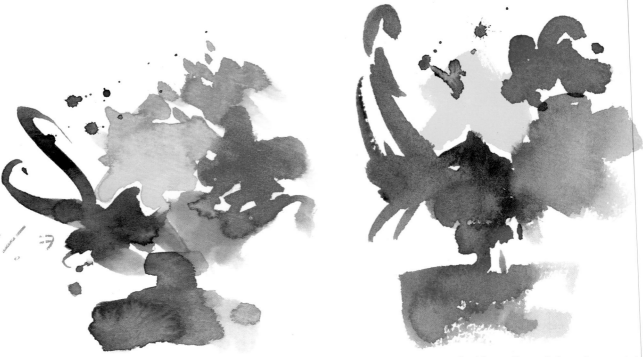

Warm hues: The blue contains red, and the green contains yellow. These colors have a warm effect.

Cool hues: Now all the colors contain blue, which gives them a cool effect.

Is snow really white? If you look at it closely, you'll be amazed at how many colors you can find. Winter motifs can be very exciting and very colorful because snow reflects the colors of its surroundings. Of course, white dominates in a winter landscape, and working effectively with both white and color is the challenge of painting such a motif.

In the example to the right, the artist applied ultramarine blue with a lot of water to dry paper and let it run into the white areas. The gentle touch of ochre gives the picture more color. After the sky had dried, the artist stippled in the snowflakes with opaque white.

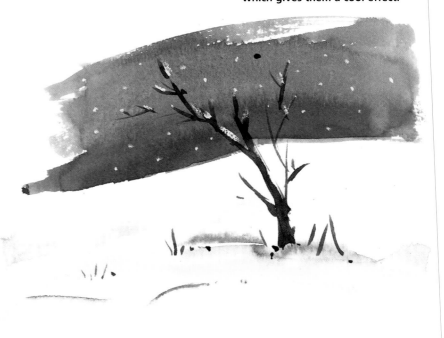

14

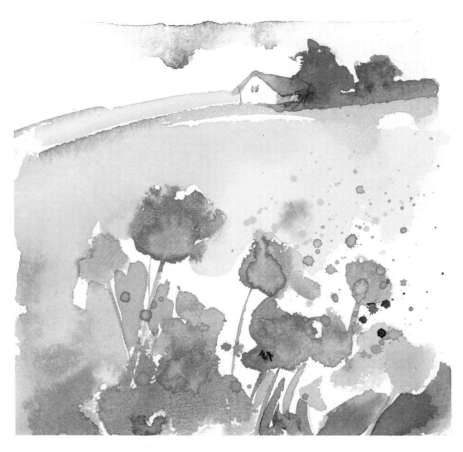

How does this painting affect you? The motif is neither especially happy nor especially sad, but it still has an overall effect that is warm and cheerful. This effect is due solely to the colors. The warm reds and yellows in the foreground remind the viewer of summer and warmth, and the bright colors give the entire painting a sunny effect. For practice, paint a few small color sketches of simple landscape motifs. Try to create different moods using color alone.

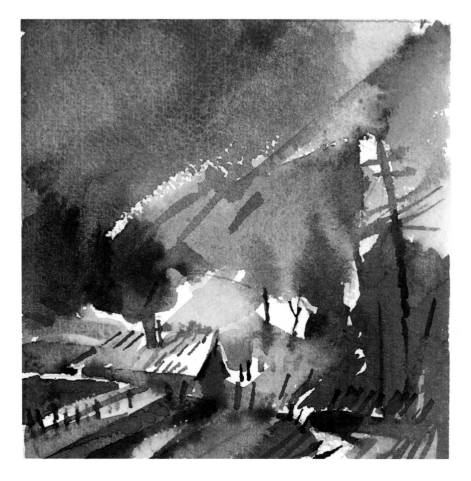

The opposite mood is conveyed here. This landscape appears cold and forbidding. Again, the motif is not dramatic, but the colors give the painting a cold, menacing effect. The white areas give the impression of snow, and the blue takes away any warmth of the alizarin crimson.

Ultimately, you must decide what mood is important to you and what colors you want to use. You have to understand warm and cool colors, though, and be able to use them correctly so you won't be surprised by unwanted results.

Weather

Practice working wet-in-wet to create clouds and rain.

Weather is always a favorite topic—even in landscape painting. Although most people are happy when the skies are clear and beautiful, painters usually find this kind of weather boring. Interesting cloud formations, a dramatic sky, or concealing fog are much more exciting than mere sunshine. Yet it is not easy to depict these weather phenomena—all the more reason to practice!

Observe the light and dark areas of clouds. Most of the time, the bottom of a cloud is darker than the top—but this is virtually the only rule. Storm clouds and fluffy clouds have different textures, and the same cloud looks different before rain begins than it does during rainfall. The wet-in-wet technique is suitable for turbulent skies: the paint-runs often form clouds on their own.

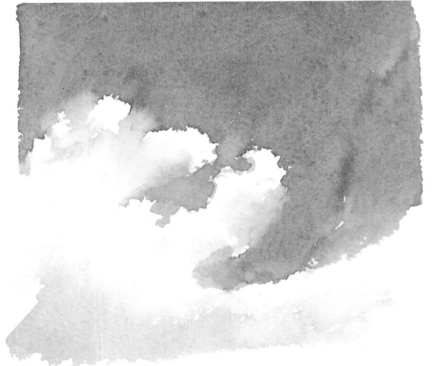

You can also use the wet-on-dry technique for clouds, indicating rain with fine brush strokes on paint that is almost dry. In the painting above, however, the artist used a different technique. First the paint was brushed outward from the center with a stiff, flat brush. Then the artist went back to the sky, this time with violet, while holding the paper diagonally. The paint ran into the jagged edges of the rain and emphasized them.

Laurie Sartin prefers the following technique, which is illustrated at the left: paint around the clouds, leaving them white; then pull the wet paint into the white area—the dark from the top and the light from the bottom. He uses a brush that is not too thick (a number 6 or a number 9) and clean water. The beautiful, misty hues are a mixture of Prussian blue, burnt umber, and violet.

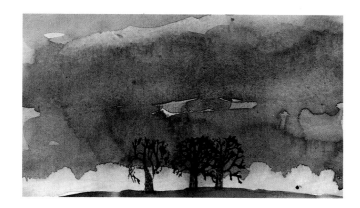

Four layers of paint were applied here, and then the paper was tilted to create a rainy effect. The sky appears especially gloomy because of the contrast with the light horizon.

The artist bought a rubber stamp of a tree at a flea market. Brown watercolor was applied to the stamp, and it was pressed onto the clouds in the painting. This technique emphasizes the gloomy mood even more.

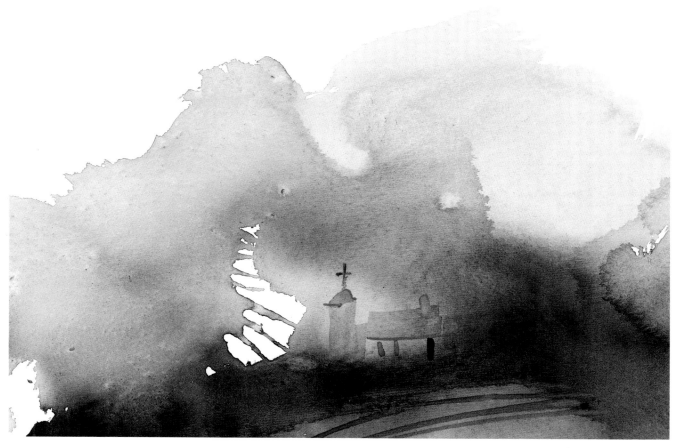

Fog tends to blur colors and shapes, and contrasts get lost. This effect can be exciting, but it is not easy to create. The color scheme should be virtually monochromatic, and you should avoid sharp contrasts. The colors of the objects and the background can blend and be repeated. Glazing is a good technique for foggy scenes because shapes often appear to shimmer through fog.

Eberhard Lorenz applied wet grays and browns to the painting above. After the base coat dried, he laid in the church with glazes, allowing the hues underneath to shimmer through.

The painting to the right illustrates another option. You can use a stiff, flat brush or even a crude brush to apply wet paint with bold strokes. The paint shouldn't be too wet, however, so that the strokes can leave random areas of white within the areas of color.

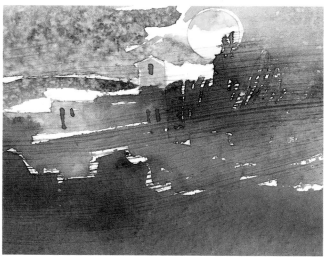

Techniques to Try

Using the finished painting as an example, Eberhard Lorenz explains the different techniques he used to create it.

First, I roughly sketched the composition; it doesn't matter whether the pencil marks can be seen when the painting is finished. Then I wet the paper with a sponge, being careful not to wet it too much. I didn't want any unnecessary "puddles."

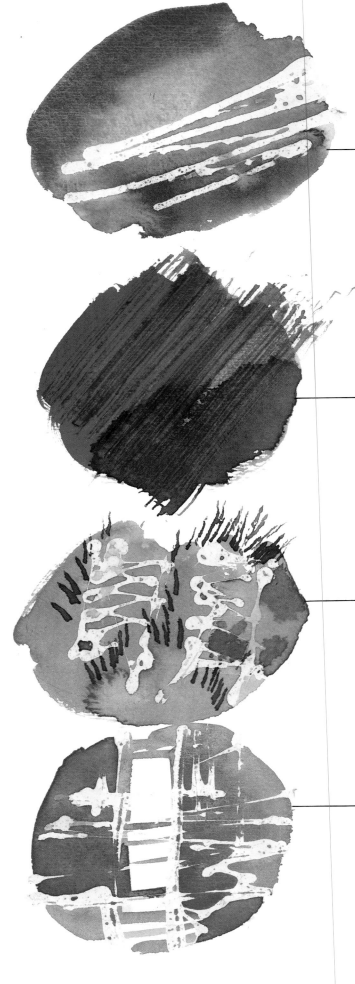

Wet-in-Wet with Liquid Frisket

In the example at the top right, the colors run softly into one another on the damp paper, and the paint forms beads on top of the frisket. If you want to keep beads like these in your paintings (often a useful technique when you're painting water), simply don't rub off the frisket. If you want an area of pure white, however, remove the frisket after the paint has dried.

Painting Rain

In the second example at the right, I went over the moist paint with a stiff-bristle brush to indicate rain. What looks like strokes of color here are merely streaks in the paint. The bristles carry the dark areas into the light areas, and vice versa. In some spots, the paint is scratched off almost completely, and white lines appear. You can use this technique to create texture for many motifs—for example, grasslands and cornfields. The brush strokes don't always have to be as long as they are here; you can also obtain interesting effects with short strokes.

Wet-on-Dry

I let the paint-runs dry completely in the third example at the right, and then I went over them with a number 6 flat brush and darker hues. I held the brush perpendicular to the paper and stippled in the small lines; the strokes change, depending on the way the brush is held.

Drawing with Liquid Frisket

In both the top and bottom examples, I held the tube of frisket as I would a pencil and drew the reflections in the water. Afterwards, I went over the frisket with wet paint and guided the colors into one another. Blue streaks crisscross the tree trunks to create a more obvious impression of water.

Colors used:

ultramarine blue
burnt umber
cadmium yellow light
brilliant purple

Brushes used:

round sable number 12
flat sable number 6

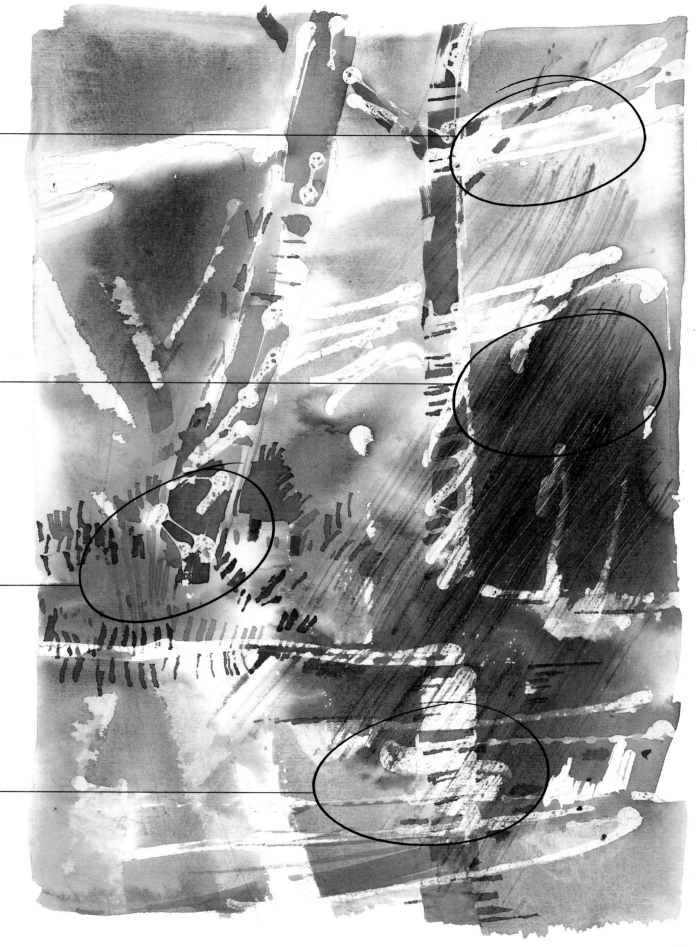

19

Learning to See

Perhaps you're thinking, "Seeing isn't something you can learn!" Yet you've probably had the experience of seeing certain objects or effects—in a landscape, perhaps—that nobody else noticed. Three painters can sit before the same motif, and each will create a different painting, mainly because the three find different things important. One may be struck by the beauty of a red roof and emphasize it in a painting, while another may ignore the roof in favor of a crooked willow tree that seems particularly interesting.

When you're just starting out in landscape painting, it is especially difficult to decide what to include in a picture. Basically, you have to choose a section of the landscape to re-create in watercolors, a task that leads directly to another problem: transferring your motif to the paper. Painting is a matter of capturing a motif on a piece of paper and making it appear three-dimensional. To do this, you have to simplify it. You have to try to reproduce the overall shape, avoid becoming lost in the details, and

concentrate on the important elements. After all, you can't paint each individual leaf on a tree.

Basic shapes can help you simplify your motifs. Most objects can be reduced to five basic shapes: square, triangle, circle, oval, and rectangle.

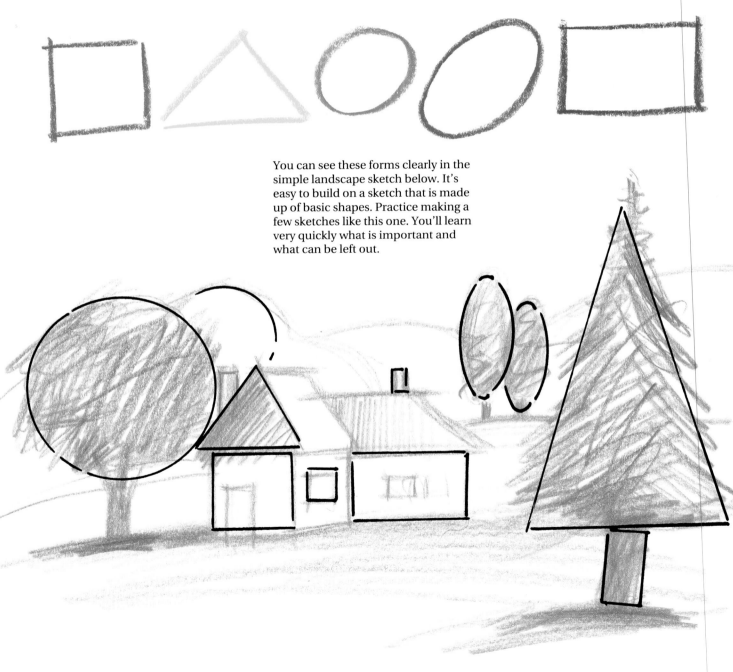

You can see these forms clearly in the simple landscape sketch below. It's easy to build on a sketch that is made up of basic shapes. Practice making a few sketches like this one. You'll learn very quickly what is important and what can be left out.

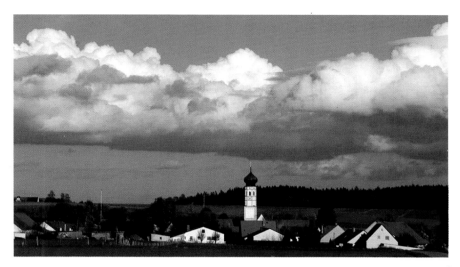

Consider an example—the photo at the left. The village hidden behind a hill and the fluffy clouds overhead form a nice scene. It inspires you to paint.

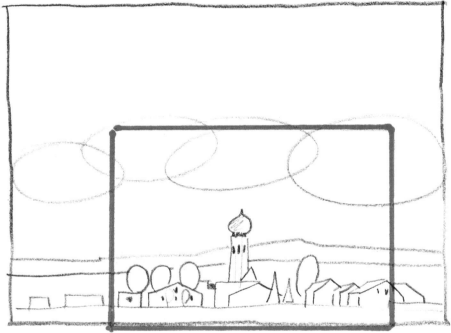

To find out how this motif can be transferred to paper, the artist first reduced it to basic shapes. As you can see, the predominant shapes are the circle, the oval, the triangle, and the rectangle.

The composition is interesting, with the dominating hill and the small buildings, but the artist didn't want to have so many clouds. A decision was made to concentrate on the village, so only a portion of the motif was selected.

Simplifying the scene helped the artist decide what is important. Now the sky doesn't play as significant a role as it does in the photo. The artist emphasized the buildings more and underscored the mood with clouds. Never feel obligated to paint exactly what you see. View nature as an inspiration, and transform it according to your own impressions.

What would you do with this landscape? Make a few sketches using basic shapes.

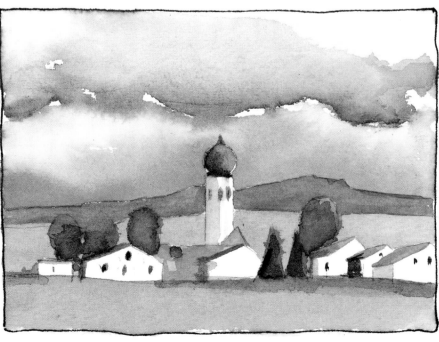

21

Positive and Negative Space

A composition does not consist solely of the motif that is depicted. The shapes that form between the individual objects are also important.

When you see an object in nature, its outline is its only border. On paper, however, the same object acquires borders that are determined by the format of the page, which is usually rectangular or square. When you place your motif in this "frame," shapes are created between the edge of the paper and the pictured objects, as well as between the objects themselves. This negative space is just as important in the composition as the positive space. Take a look at a simple example: the tree on this page.

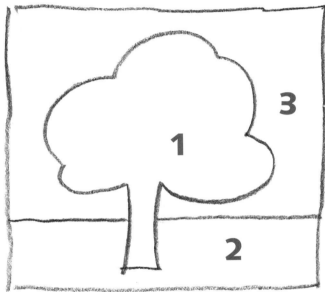

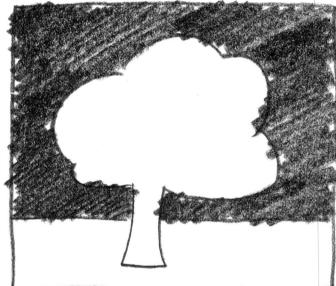

If none of the areas in the composition is particularly emphasized, you see a tree on a surface because that is what you've learned to see. Precisely speaking, however, there are actually three shapes: the tree, the ground, and the background.

The expressive dimension of a painting requires all three of these shapes. If you want the tree to be the most important element, emphasize it. Perhaps the most important element in the composition is the stormy sky, however; then the tree plays a less important role, and you must make the background the prominent element. If you want to emphasize the meadow, concentrate on that shape. As you can see, the negative space is a critical part of the composition and must be planned just as carefully as the positive space.

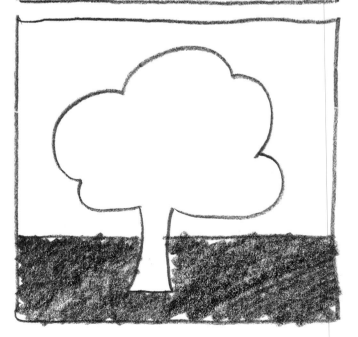

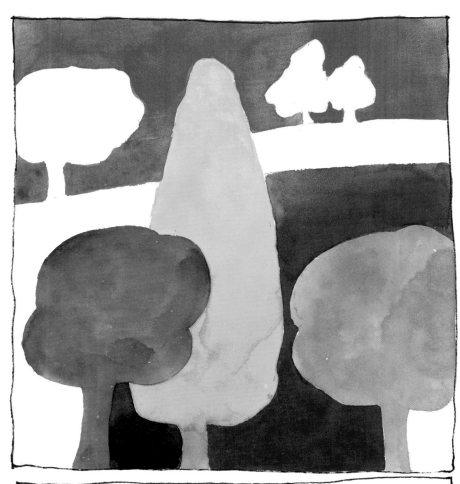

Now apply this concept to a more complex example. Here are two different pictures, although they both involve the same composition. The artist has simply played with the positive and negative spaces to show you how important they are.

In the top painting, for example, the large trees appear in the foreground. The small ones, in contrast, serve merely to support the shape of the red background. In the bottom painting, the small trees stand out clearly against the background. The large trees in the foreground give the impression of holes, but they give form to the surrounding shapes.

In this example, the artist isn't concerned with the expressive element of color—whether it is cool, warm, happy, or melancholy. The only purpose is to show the many possibilities of working with shapes and space.

Try a few simple compositions on your own. See what kinds of shapes occur between the objects. It's also interesting to look at famous paintings in this regard.

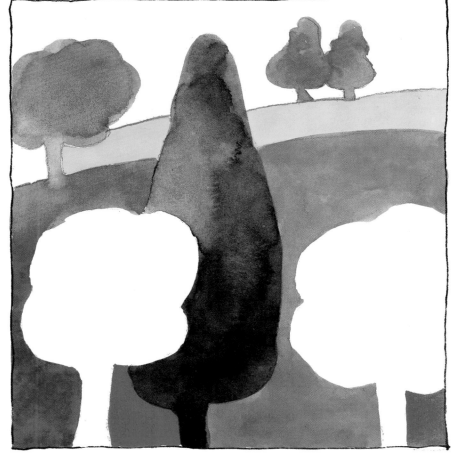

Creating Depth

You have seen that depth can be created by overlapping the shapes in a painting and by changing their size. Colors, too, can determine whether the painting appears "flat." The wrong color can destroy the depth you thought you had created in the composition.

A few rules of landscape painting can make your work easier as you experiment with depth. As is true in the case of everything in painting, however, you can discard them when you no longer need them.

One rule is that objects that are more distant appear not only smaller but also less distinct than objects that are close; the atmosphere between the objects and the viewer gives the impression of haze, gray, and softness. Therefore, objects that are close appear more detailed; they are sharper and darker than distant objects. This observation leads to a simple rule: things that are closer are darker than things that are more distant.

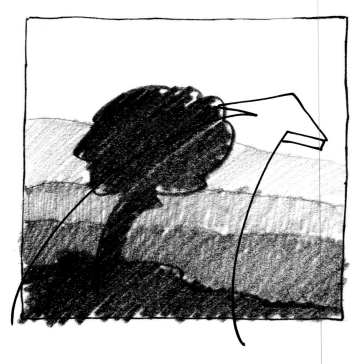

You can try this easy exercise to train your eye: Sketch a simple landscape with a soft pencil. Begin with a dark foreground, and work your way to lighter shades. Then try the same thing in color. Create a color value scale with five or six shades. Then make small sketches with these colors, concentrating on creating depth. In this way, you'll become familiar with the effects of tonal value, and you'll gain confidence in creating color compositions.

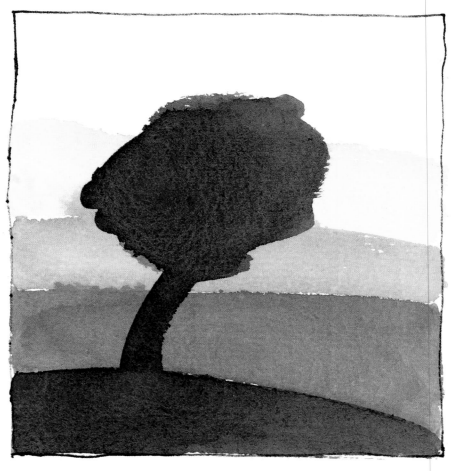

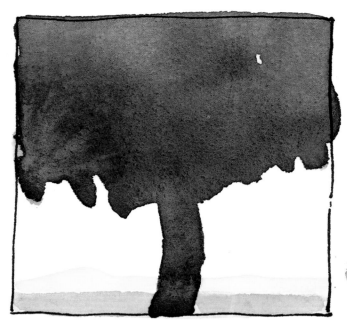

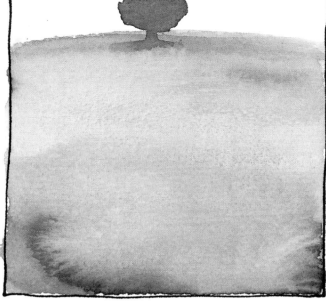

Closeness

Notice the effects of tonal values and the distribution of space in these small example sketches. The large, dark tree above appears very close. The eye almost has to look around the tree to see the light hills further in the background.

Distance

In this example, nothing distracts the eye on its way to the focal point, the small tree. The large, green area leads the eye directly to the tree, the small size of which emphasizes the impression of distance.

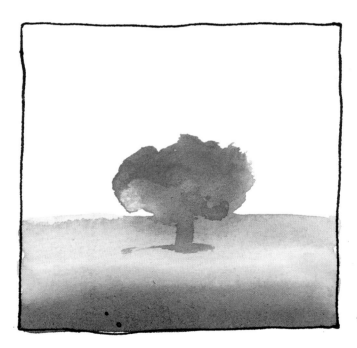

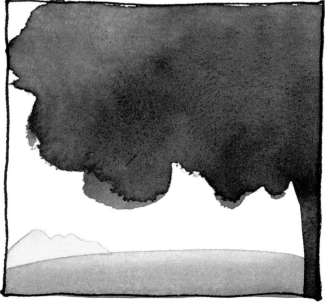

Tranquility

All the areas are balanced in the sketch above. The shapes are not exaggerated, and the colors are not extreme. The tree appears almost exactly in the center of the painting, and there is no tension in the composition. Everything is harmonious and even, giving the impression of peace.

Tension

The opposite quality is seen in this last example. The center of the composition is empty; the tree at the extreme right draws the eye out of the picture, and the hills to the left have the same effect.

Working with Light and Shadow

You have learned how to simplify the motif and organize the distribution of space within a composition. It is also important to understand how to make the objects in paintings appear three-dimensional. When you draw outlines, you can recognize the objects, but they appear flat. An object doesn't get its three-dimensional shape until you add light and shadow. Shadows make circles into spheres and squares into cubes.

The tree is a good example of the way light and shadow lend form to painted objects. If you simply draw an outline of the tree, you can recognize it as such, but it looks flat. Instead, imagine light coming from the upper right. When the artist adds the corresponding shadows, the tree takes on shape—the top and the trunk look round.

Painters differentiate between two kinds of shadows: the core shadow and the cast shadow. The core shadow—that is, the shadow on the object itself—gives the impression of three-dimensionality. The cast shadow shows an object's position—that is, whether it's floating in space or standing firmly on a surface.

The core shadow is always lighter than the cast shadow, because the core shadow is illuminated by reflected light.

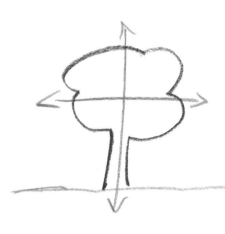 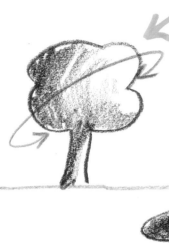 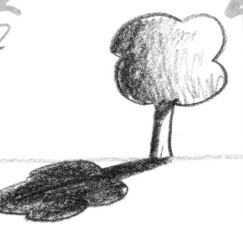

In landscape painting, the sun is the most important light source; artists simply cannot create the shadows they like, as they can with artificial light. The shape and the length of shadows in landscape depend on the position of the sun. The shadows are shortest when the sun is directly overhead at midday; the further the sun sinks, the longer the shadows become; and the further the sun rises, the shorter the shadows become.

Now the sun is directly overhead. The shadow is short and shows only that the object is standing on a surface.

Here the sun is in the upper left, and the shadow is not very long.

In this example, the sun is on the right side of the tree, and the shadow is long.

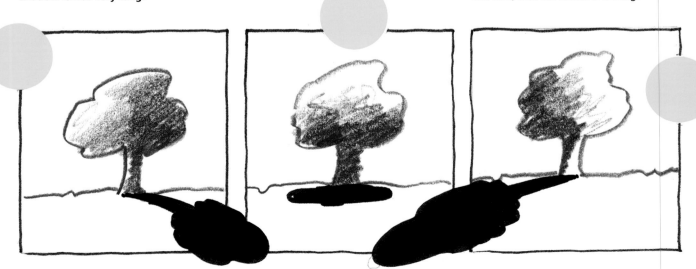

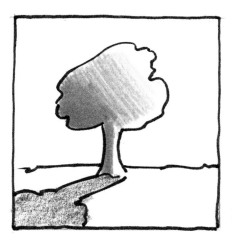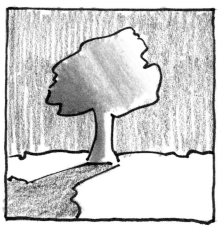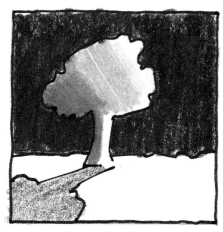

The surroundings also influence the shadow. Does the shadow have the same tonal value in all three examples?

The tonal values are indeed the same, but the shadow seems lighter against the dark background and darker

against the light background. Notice, also, that the cast shadow is darker than the core shadow.

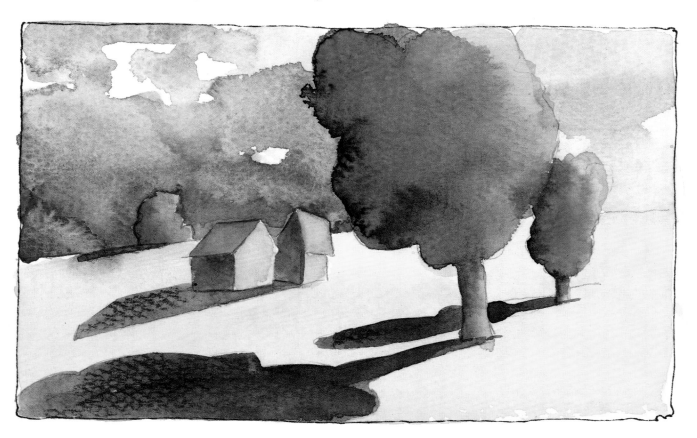

Unfortunately, there is no recipe to tell you what colors to use to paint a shadow. One thing is certain, however: a shadow is never simply gray or black. You can find all possible colors in a shadow. In nature, shadows often have a blue hue because they reflect the sky. A red wall or a yellow car can also have an influence on shadows, and the surface on which a shadow is cast plays a role, too.

In the picture above, the artist has given a brown base coat to the shadow on the area of yellows and ochres. A little green pulled in from the trees and some blue from the sky make the shadow livelier.

The watercolor medium itself makes painting core shadows easy because you can use the paint-runs to express the shape of an object.

Putting It All Together

This is a good time to take a look at the individual elements of composition in a finished painting so that what you've learned so far isn't simply theory for you. The street with the telephone poles (below) is a clear example of creating depth in a painting. Of course, perspective plays an important role because the vanishing lines give the impression of distance.

You can easily recognize the basic shapes—they are mostly rectangles and triangles. Not only the roofs are triangles, but the mountain between the poles and the house is a triangle, as well.

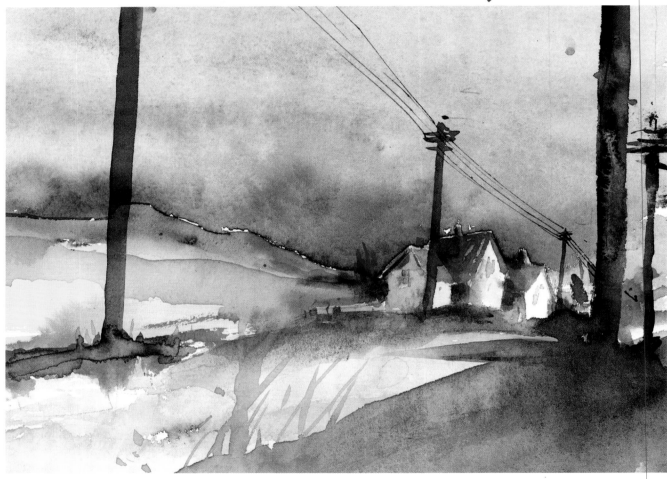

The interplay of positive and negative space is also interesting in this composition. The negative space is just as important as the positive space because the somewhat threatening sky is just as important as the landscape itself. To illustrate this relationship between the two types of space more clearly, the artist has sketched the same motif in black and white and switched the areas.

The poles and the foreground are easy to recognize as positive shapes, and they dominate the picture.

Here the artist has emphasized the negative space. You can see that it is also important.

The painting on this page is built entirely on the basis of light and shadow. The artist intentionally left out the sky because the focal point is the colors of the trees. You don't always have to paint a picture all the way to the edge to create an interesting mood. Light and shadow form the shapes of the trees, and the core shadow gives the trunk its roundness. The cast shadows of the houses make them stand firmly on the ground.

In this example, the light comes from the upper right, and the shadows correspond.

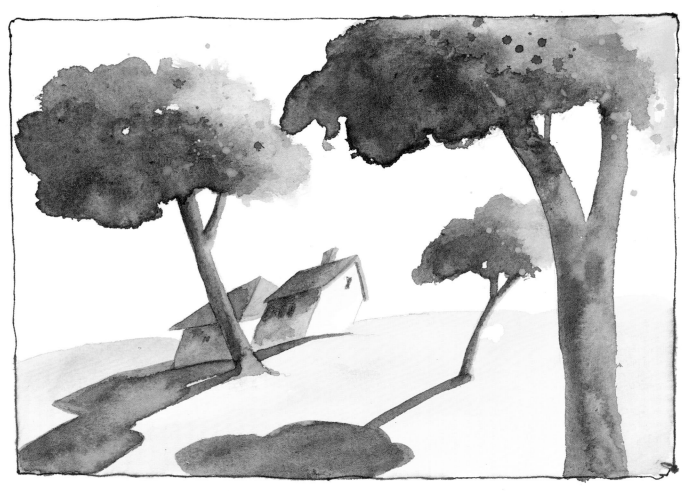

The unusual lines never let the eye rest because the individual elements are virtually equal in weight. The exaggerated light in the painting reinforces the feeling of autumn. When you create unusual compositions such as this one, it's helpful to first make a few sketches to familiarize yourself with the basic shapes.

Small, basic sketches often help to clarify perspective.

The eye is led outward, a movement that creates tension.

Sketches

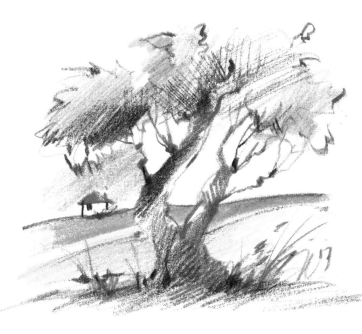

Often you're inspired by a landscape. You feel that you want to paint it, but you don't have any equipment with you. Later, at home, it's difficult to remember how everything looked, so you don't paint the scene. Perhaps you've also experienced another, similar problem. Sometimes at home, you feel the urge to paint, but you don't know what to paint. In such cases, a sketchbook is extremely helpful. It doesn't have to be big. You can carry it everywhere, and you can use a pencil, a marker, or even a ballpoint pen to jot down ideas or impressions.

But just what is a sketch? A sketch quickly captures an image you don't want to forget. It can be an idea, a motif that pops into your head, or an experience that you want to preserve. Sketches are especially important in landscape painting because they help you remember trips you have already taken.

Sketches can also be a form of preparation for a painting. You can try out different compositions or color schemes, depending on what you want to paint. This doesn't mean, however, that sketches are always secondary. As works in their own right, they have a certain charm in their spontaneity and incompleteness.

On a trip, a sketchbook can become a kind of diary that is more personal than a collection of photographs. If you make a habit of taking your sketchbook with you wherever you go, you'll soon have a large supply of motifs and inspirations that you can turn into paintings. It doesn't matter, then, what kind of paper you use. A sketchbook that has a cover page is practical because it protects the pages inside. Notebooks are also suitable, as is a bound book with empty pages. The advantage of a bound book is that you don't need a surface on which to rest your paper while you sketch.

The example above is a small colored-pencil sketch done to capture the cheerful mood. The artist found the red roof—and the same color repeated in the flowers in the foreground—particularly interesting and was only concerned with colors here, not with the types of plants.

The artist made the sketch below on a trip through Turkey. The many different kinds of trees were fascinating, and they were sketched quickly with a soft pencil.

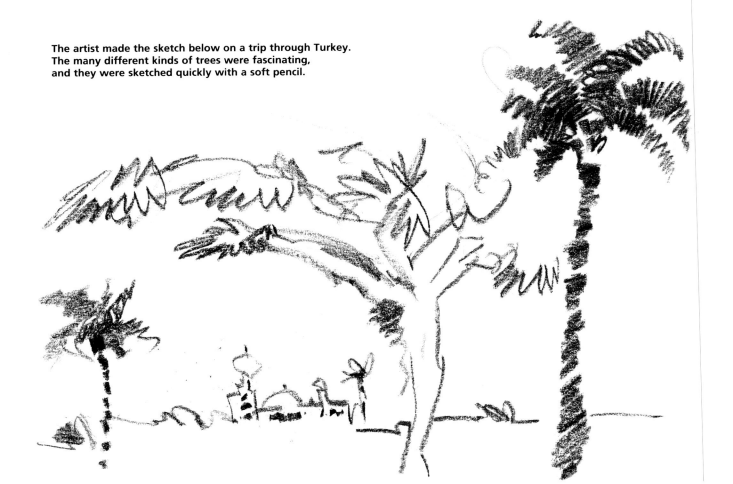

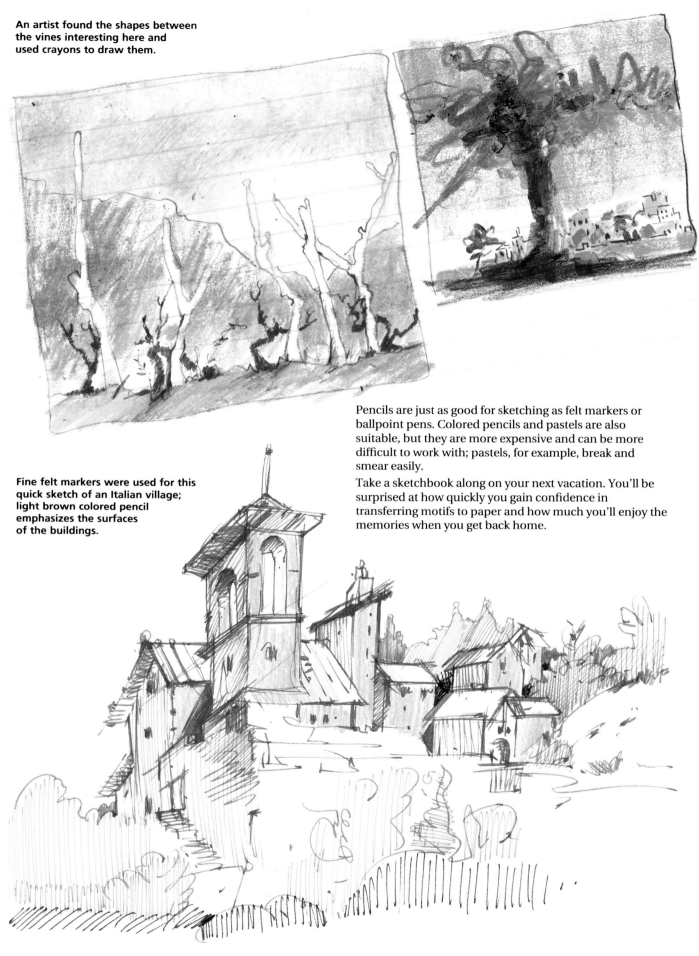

An artist found the shapes between the vines interesting here and used crayons to draw them.

Pencils are just as good for sketching as felt markers or ballpoint pens. Colored pencils and pastels are also suitable, but they are more expensive and can be more difficult to work with; pastels, for example, break and smear easily.

Take a sketchbook along on your next vacation. You'll be surprised at how quickly you gain confidence in transferring motifs to paper and how much you'll enjoy the memories when you get back home.

Fine felt markers were used for this quick sketch of an Italian village; light brown colored pencil emphasizes the surfaces of the buildings.

Painting a Rainy Landscape

with Laurie Sartin

I'm continually fascinated with painting wild, dramatic cloud formations, perhaps because as a child in England I was enchanted by the wild clouds that formed over the sea off the rugged east coast. Watercolors are especially suitable for painting clouds, which can form spontaneously in the wet paints.

If you simply let different hues run into one another, cloudlike textures eventually form; using this method, however, you have to rely on coincidence and chance. There are several ways to paint clouds intentionally, and I would like to show you a few of my favorite techniques.

You'll eventually develop your own preferences for techniques and color combinations. Perhaps you'll even discover a new way to paint clouds.

1 Paint around white areas.

3 Blend the colors softly.

2 Apply Naples yellow.

Painting Soft Clouds

Of course, the colors you use determine the mood the clouds project. Yet, the way you blend the colors and create edges also plays an important role.

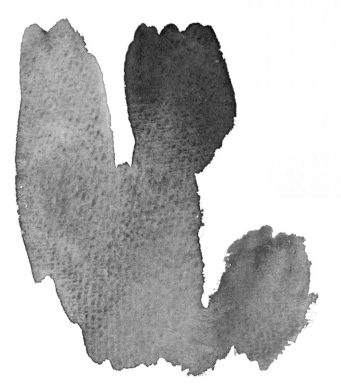

Here I use cerulean blue mixed with a touch of burnt umber, and, as I apply the paint, I leave areas of the paper white where I want the clouds to appear. Next I go over these white areas with Naples yellow and softly blend this color with the damp blue. The edge along the dark area of the sky is not hard; the clouds and sky blend in the wet paints. The most difficult part of this technique is achieving the proper consistency of the paint—it can't be too wet or too dry.

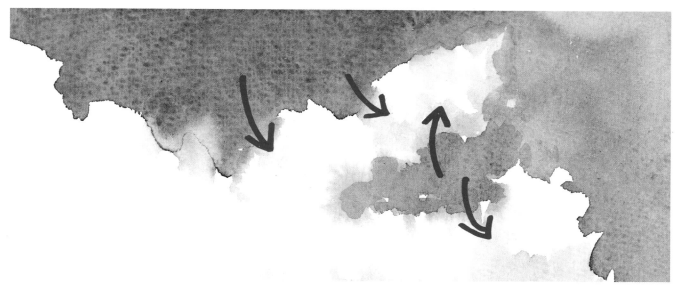

Painting Clouds with a Hard Edge

The example above illustrates a technique that affords many different ways to play with color. I paint the dark hues first, leaving the white areas of the clouds unpainted. While the paint is still wet, I take a fine brush (number 6) dipped in clean water and blotted dry. (If the brush is too wet, it makes unwanted splotches.) With this brush I blend the paint into the white areas. I leave a lot of white because it gives the clouds their luminescence.

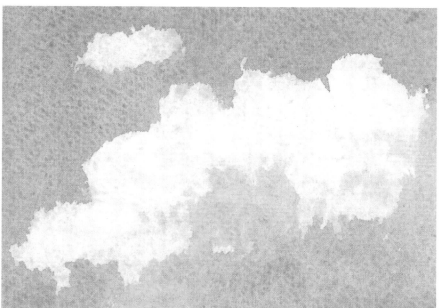

Lifting Out Clouds

This technique involves applying a base coat and lifting out the clouds with a tissue or sponge. This procedure sounds simple, but it has many variations. A sponge creates textures different from those made by a tissue or paper towel.

In the center picture at the left, I lift out the clouds with a cloth and paint in the upper contours. In the bottom picture at the left, I lift the paint with a damp tissue. Of course, you can continue to work the paint and apply a glaze, for example, or other colors. Try it!

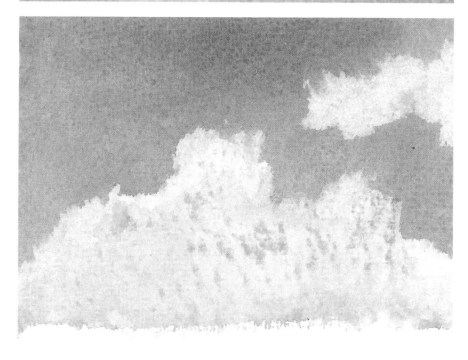

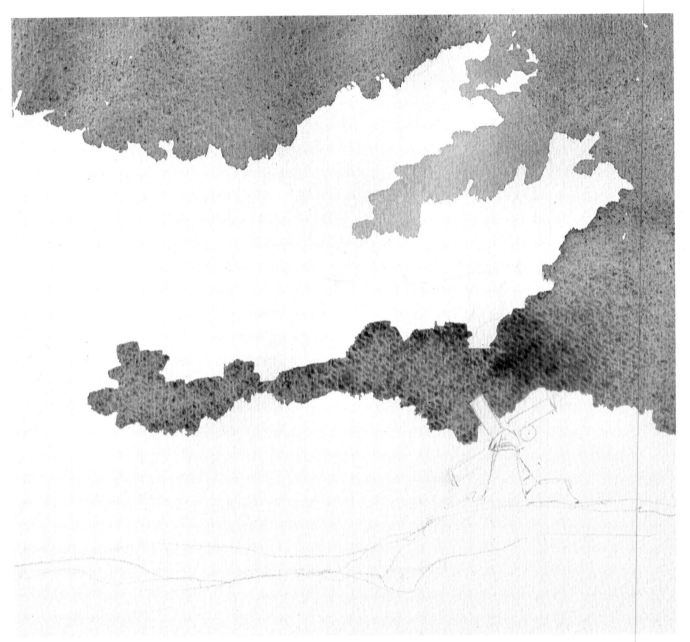

I throw away the first sketch (far left)—the clouds look as though they are in a sandwich. The darkness around the windmill in the second sketch (left) heightens the drama. Perhaps I'll put in a light strip between the windmill and the clouds. I make all my sketches with light pencil marks. Because the clouds are the most important element in the painting, I begin with the sky. My basic colors in this painting are burnt sienna, Prussian blue, and a touch of violet. I create darker areas by adding more violet.

Before I begin the actual painting, I make a few sketches to work out the composition and tonal values.

I also decide on the direction in which the wind blows because wind direction determines the shapes of the clouds, especially in stormy weather.

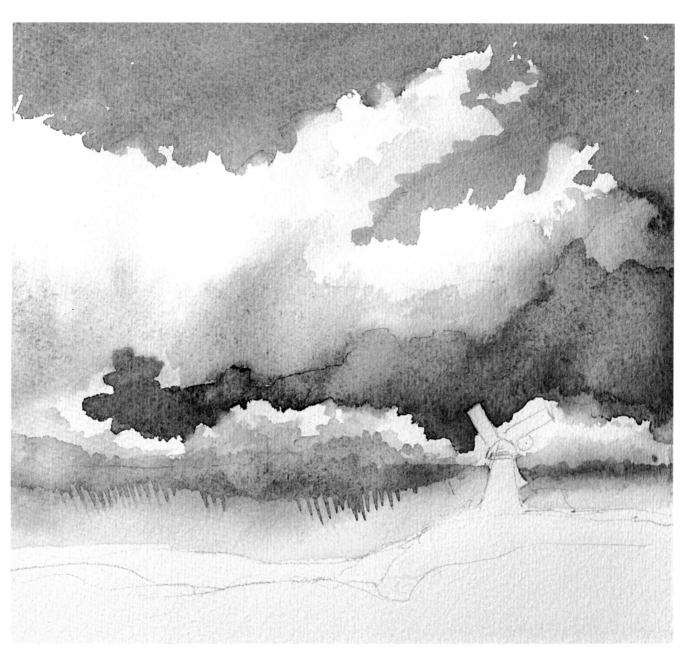

As I demonstrated on page 33, the hard white edges of the clouds have to be softened before the sky dries. I then use the color that collects on my brush for the shadows in the clouds. I use a lot of water to thin the colors I mix on the palette and work with the resulting hues to add highlights.

Remember to leave a lot of white space because you can't restore white once paint has been applied.

For the light strip, I choose Naples yellow, which I work into the sky. A fine brush "pulls" the rain out of the sky toward the bottom of the picture.

Above and to the right are a few attempts at the rainy strip along the horizon, which is a blend of gray and Naples yellow. Both colors are applied wet from top to bottom.

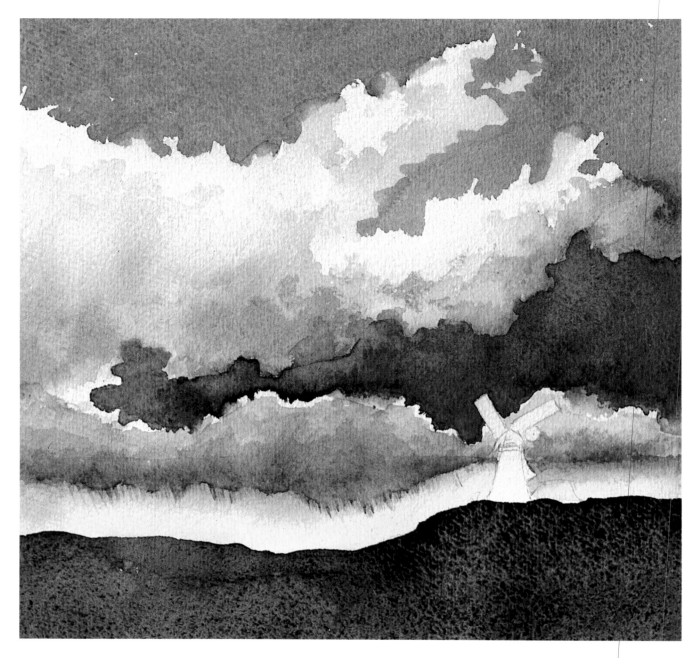

Now it's time to concentrate on the foreground. Of course, a summer meadow wouldn't be appropriate for the rainy, windy mood here. I want a lonesome, barren landscape in which the dampness can be felt. I mix Hooker's green and burnt sienna and lay in the hills around the windmill. I'll save the windmill itself until the end, when everything is dry.

At this point, the dark green in the foreground weakens the effect of the sky, so I need to create more contrast. I darken the middle of the sky by adding highlights in violet and sienna.

I intentionally leave the white strip under the lower cloud as a highlight. Even in gloomy clouds, you can find highlights that emphasize the shapes and give the clouds three-dimensionality.

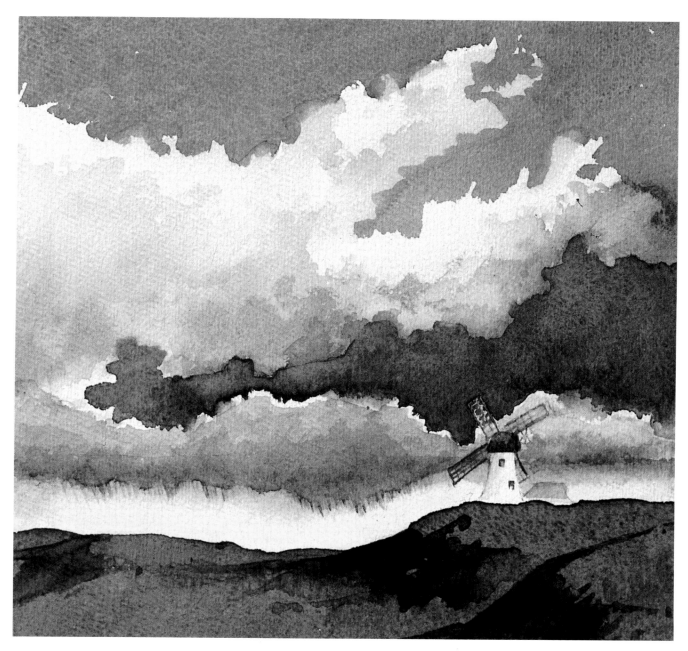

Before the green is completely dry, I add the shadows of the hills with a little more burnt sienna mixed into the green paint on the palette.

The final step involves adding details and making improvements to the dried painting. These details should stand out and not run into the painted areas around them. The end stage is when I add the roofs, the windows, and the blades of the windmill.

To make the windmill more three-dimensional, I add a light shadow, its color mixed from the blue hues of the sky.

Maybe you'll get some ideas from the small sketch to the right, which combines several of the techniques I have described. In this example, I leave the upper clouds white and paint them later. The lower clouds, however, are lifted out of the slightly wet paint with a tissue. Then I hold the brush flat and pull down uneven amounts of paint from the sky to create the rain.

Make some small sketches of different cloud formations. Simply do what you think will please the eye. This experimentation will help you build confidence in using color and technique.

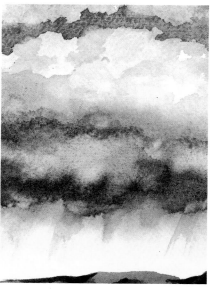

Painting Reflections

with Eberhard Lorenz

I always find landscape painting exciting because the inspiration comes from nature, but I give it form. I consider it my obligation to see nature anew and to depict my impressions thereof. When I'm on vacation, I often paint outdoors—I simply paint wherever I am. I also paint from memory at home in my studio, without looking at a photo. After all, if

I always do a few pencil sketches in black and white to get a feel for the tonal values and to decide where the focal point of the composition should be.

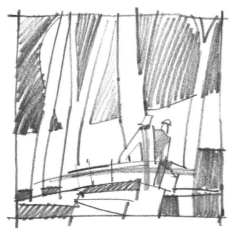 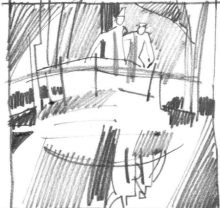

1. **Sketch at far left:**
 The focal point is at the bottom of the picture, and the reflections play an insignificant role.

2. **Sketch at left:**
 The reflections dominate the composition, and the figures add balance.

3. **Sketch below:**
 The scene on the bridge is the focal point, and the reflections serve to enhance the overall composition.

a landscape looks a certain way in my memory, I must have seen it that way. Therefore, reality is unimportant, as long as I want to express my own impressions.

I was fortunate to be able to rent a studio in the left wing of a castle, on the top floor, under the roof. Just looking out the window is inspiring, and the view provides me with everything I need—from the changing seasons and the different cloud formations to colorful hikers, horseback riders, and café patrons.

The small scene I have chosen comes from "my" castle grounds. The bridge is in a densely wooded area and leads across a brook that flows into a pond. I often go walking there, and I know this spot in all its different moods. I decide to paint it on a cool fall day when the water in the pond is as smooth as a mirror. This choice of subject means having to work with a rather difficult motif: reflections in water.

First I have to decide what will dominate the composition. Should the reflections be the theme of the painting, or should they merely enhance it?

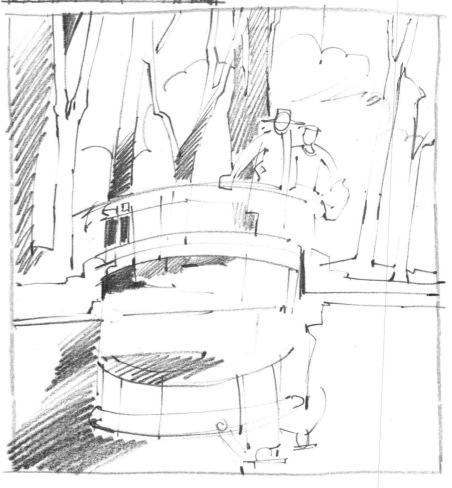

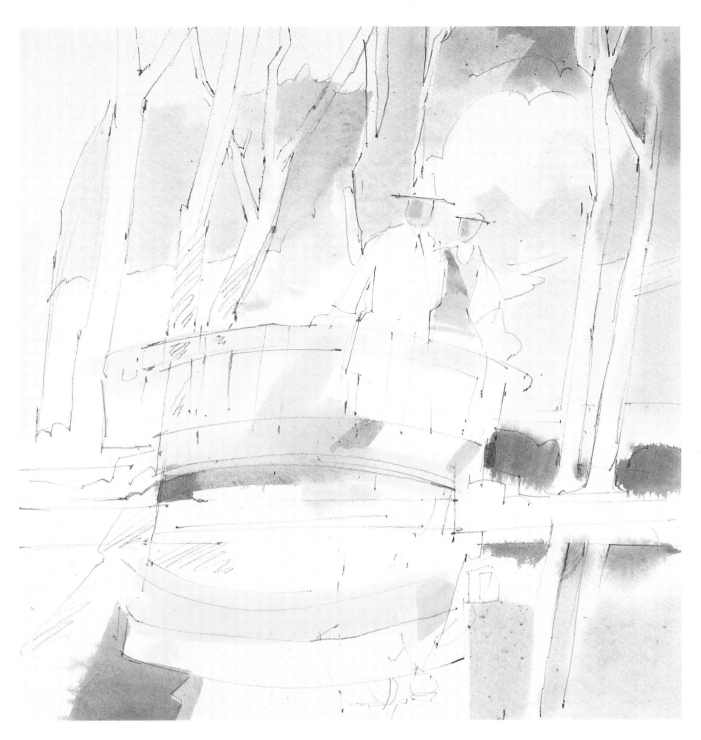

I decide to base my painting on the third sketch, which I transfer onto the watercolor paper with sparse pencil marks. It doesn't bother me if the marks are visible later because they give the painting spontaneity.

The shapes that develop between the trees are just as important to me as the motif itself. I use color (e.g., violet) to incorporate these shapes into the composition. I also lay in the initial areas with sparse colors (Prussian blue, yellow ochre, and cadmium red). I work on slightly damp paper to achieve the soft transitions from one color to another. If the paper is too wet, the paints run too randomly.

The reflections of the objects are treated in the same way as the objects themselves; the reflections and the objects should be seen as similar. At this point, I lightly apply the red accent to the figures so I can incorporate it throughout the painting, but I wait until the end to complete the figures.

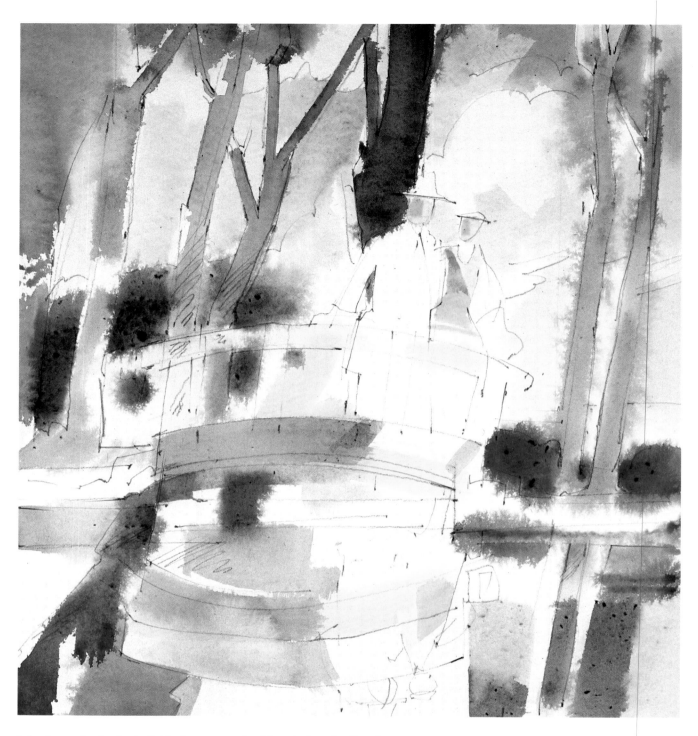

I slowly emphasize the individual elements of the painting. The tree trunks become more defined, and the Prussian blue in the background adds depth.

Reflections are influenced by movement in the water. Gentle waves cause horizontal lines, while rough water forms points and flecks. Reflections in calm water, however, look almost exactly like the objects reflected.

In this painting, the line that separates the object from its reflection becomes very important. This line can be formed by a riverbank or a group of plants, or it can simply be an indication of an edge.

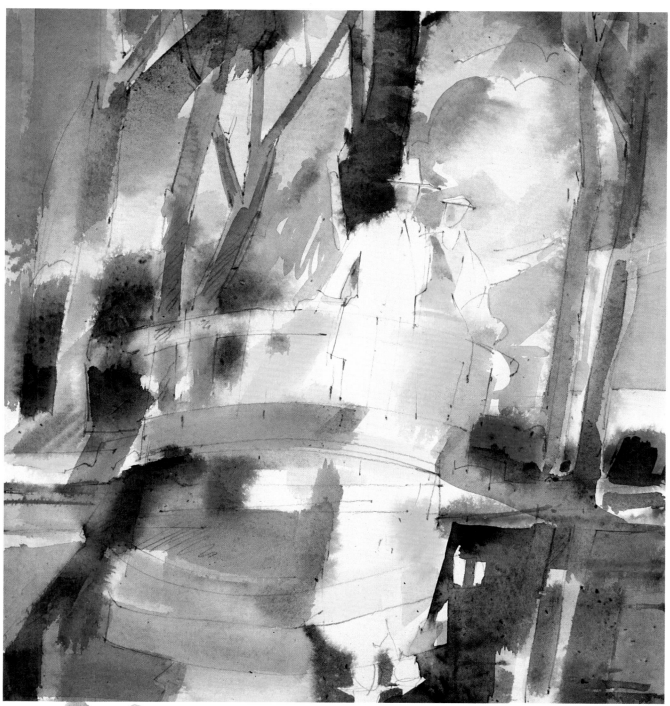

The way you apply the paint determines the difference between the objects and figures in a painting and their reflections. In the water, the colors of the reflections flow together, and the edges are indistinct. Glazing is especially suitable for reflections because some colors run and some remain on top of or next to other colors. The example at the left illustrates these effects of glazing.

Always try to keep an eye on the overall composition, and don't get lost in small details. I always apply the highlights in the background and in the reflection at the same time. When I apply yellow to the bridge in my painting, for example, I also apply it to the reflection.

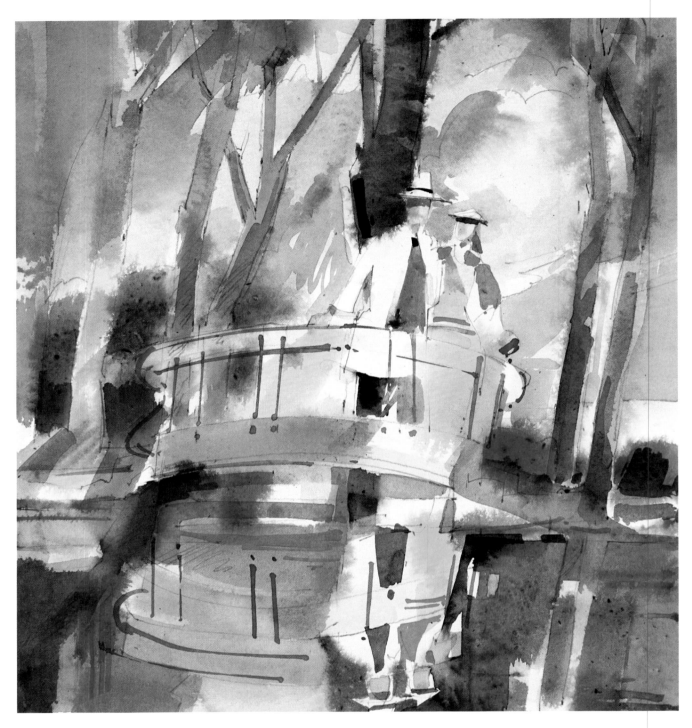

The last step involves adding the small details to the dry painting. This is also the point when I make improvements or add emphasis, if necessary.

I finish the figures' clothing with a fine brush, and I also make the landscape more detailed. A few horizontal strokes of ultramarine blue under the bridge add emphasis to the reflection, and short, almost broken lines emphasize the landscape. The reflections of the figures and the background trees form an abstract composition in the water. You can see that the basic shapes described on page 20 are visible here.

Here are a few more ideas for painting reflections. It's always helpful to make several color sketches and try out various techniques.

In the examples above and at the left, the paints are applied to a dry surface. To create reflections, I make horizontal strokes in the paint with clean water, causing the paint to blur. If it suits the motif, you can add delicate lines to the dry paint with a fine brush, as in the upper left example.

You can also produce reflections by folding the paper (see the dotted line in the middle of the example below) and pressing the two halves together after you paint the objects. Of course, the paint must still be at least partially wet. You can then continue to work on picture.

Below, the motif is simply repeated in the water and then washed off. I do this with a wet brush and then immediately dry some areas with a tissue.

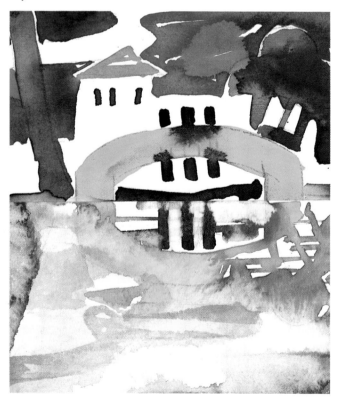

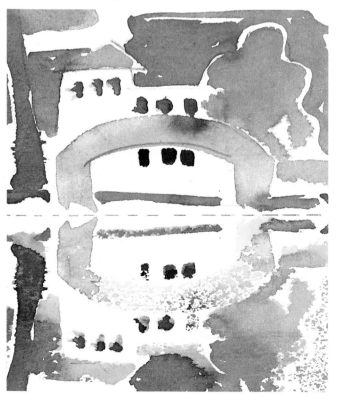

Painting a Winter Landscape

with Beate Weber-von Witzleben

At first glance, winter landscapes appear to be colorless—everything looks white. Yet, is this true? As you've already learned in connection with warm and cool colors (see page 14), snow reflects the colors of its surroundings. It can contain an indefinite number of nuances, from delicate blue to violet to pink and even yellow hues.

In sunshine, sparkling spectral reflections and extreme contrasts can occur. Below are a few examples.

Right: First I apply the sky with wet violet and yellow ochre. I let the concentrated ultramarine and umber of the trees run, and I use an old, dry brush and a touch of cadmium red for the delicate textures of the trees.

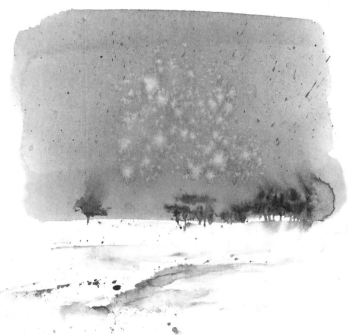

Left: During a snowfall, the fresh blanket of snow often creates a dramatic contrast to the gloomy sky. You can spatter and spray the falling snow onto the wet sky. I carefully drop water from the tip of the brush to my finger and then dab it onto the sky with my fingertip.

The best way to handle large areas of snow is to leave them white. It is important, however, to incorporate these unpainted white areas into the picture and to integrate them into the color scheme.

Right: The intense color "blooms" on the wet background. Here I use these blossoms of color as trees, which are off in the distance and therefore do not have distinct contours.

The blanket of snow in the foreground seems icy. The quality of the snow plays an important role because powdery snow has a different texture than icy, frozen snow. I achieve this icy surface by applying relatively dry paint with an old, frayed brush. Afterward, I spread the paint with my finger.

This snow-covered mountain range is a lively combination of water and paint. I paint the top of the mountain range with cerulean blue and cadmium red, stipple (make dots and small, short strokes) and spatter the rest of the picture, add water, and then tilt the paper. It is fun to play with the results and incorporate them into the painting.

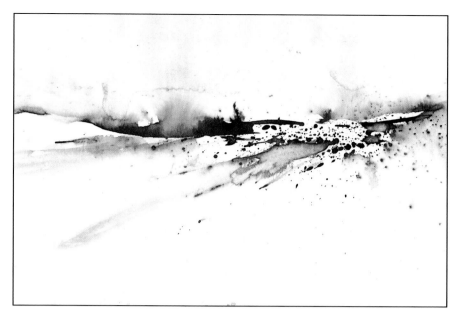

In this example, I first apply the sky lightly, with a lot of water. Then I let a mixture of cerulean blue and cadmium red run into the sky while maintaining the hard edge at the bottom, which gives the impression of the edge of a forest. Sometimes colors that are mixed on the palette separate when they run, which creates an interesting effect. Here the forest gets a mysterious, flowing blue edge.

I apply the expanse of snow in the foreground with my fingers.

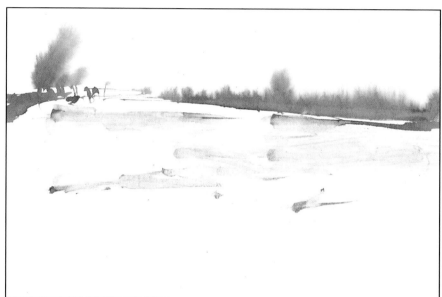

The sky is still wet when I apply the trees here. The edges of splotches form excellent tree contours. These edges, which are darker than the areas surrounding them, dry first. Later, I carefully dry the inner areas with a tissue. These lighter inner areas give the impression of snow-covered trees.

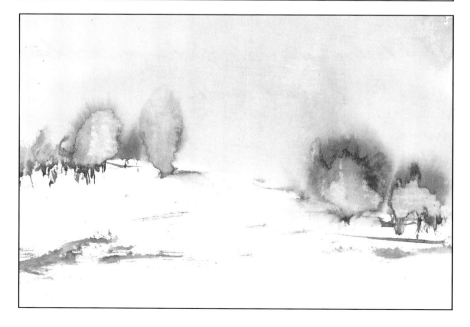

Here you can see how to create a winter landscape step-by-step. I work with a number 12 sable brush and limit myself to alizarin crimson, yellow ochre, and ultramarine blue. At the right are the many winter hues you can mix with these colors.

I use individual sheets of handmade paper. First I sketch the composition on dry paper with fine lines. Because stretching the paper is too much trouble for me, I wet it in the bathtub, lay it on a piece of Lucite or white cardboard, and smooth it out with a sponge.

I apply the water generously because as soon as the paper dries, it buckles. For this reason, I have painted the same motif four times for you, instead of photographing the individual steps. Otherwise, the painting would have dried between photos.

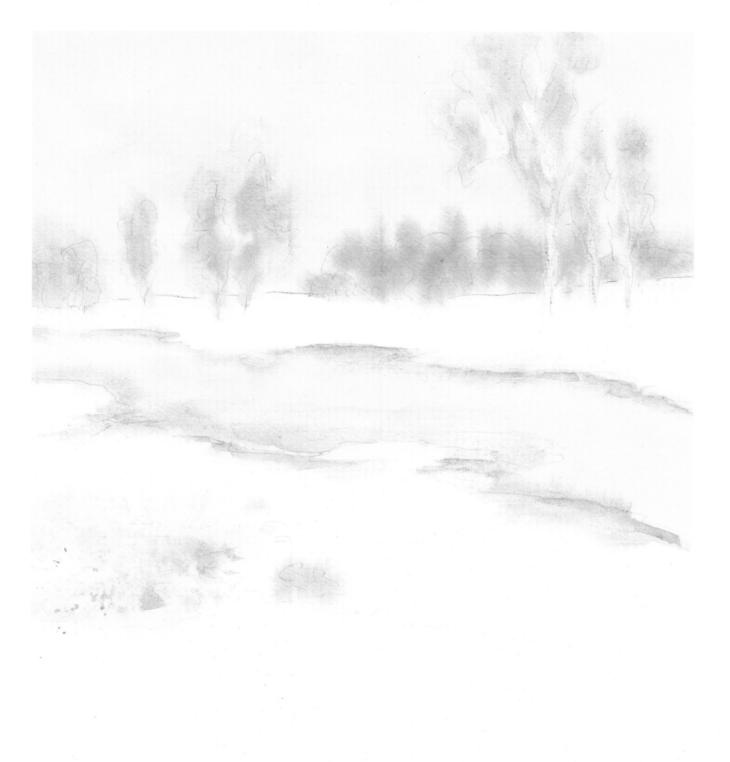

After I smooth out the paper, I carefully use a tissue to dry the areas that will remain white. Next I apply the paint (see page 46). I use yellow ochre first for the warm light, and then I use a little ultramarine blue for the bushes and the banks of the river, with a few dabs in the foreground for stones and earth. On wet paper, the paint blurs and runs into the white areas. To create more distinct edges between the snow, the horizon, and the riverbanks, I remove the paint with a dry brush.

Above: Because I apply water generously, the paper remains wet and the paint runs. A mixture of ultramarine blue and alizarin crimson is applied in splotches to indicate the trees. I lift the paint off the trunks and limbs with a dry brush.

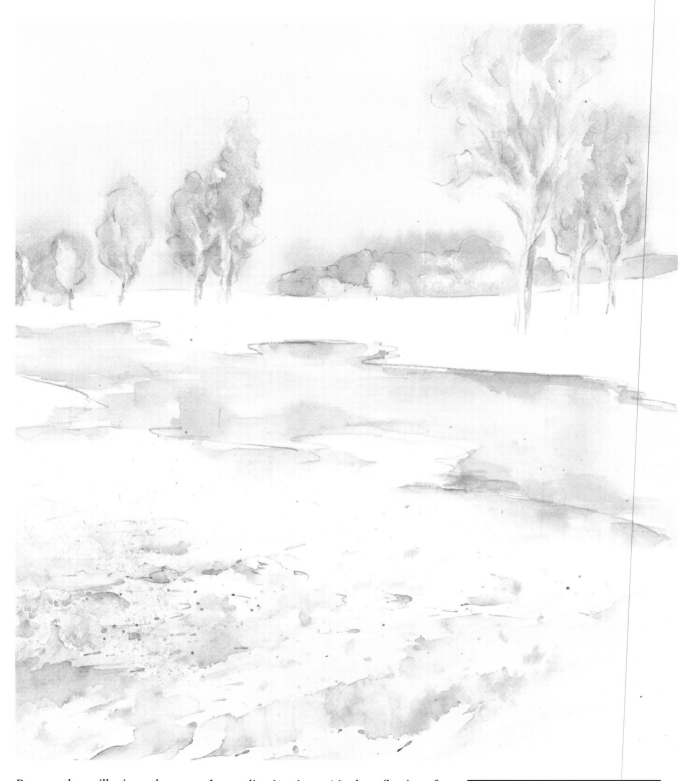

Because they will mix on the paper, I use paints straight from the tube. A limited palette like the one I am using in the painting here helps to avoid unattractive mixtures. In this example, the paper has dried somewhat, so the areas of color appear more precise, and the edges are sharper. For the reflections, I let some hard edges remain; others I soften—for example, the red (pure alizarin crimson) in the reflection of the tree at the far right-hand side of the picture. I use spatters to produce the textures in the foreground, sometimes allowing them to blur on the damp paper. This technique gives the impression of snow between the stones and gravel.

Here's a tip for you: You can control the way the paint runs without using a brush and possibly destroying the liveliness of the wet-in-wet technique. Tip the paper, or blow the paint in the desired direction. Be careful to avoid puddles, however, and soak up the excess paint with a dry brush.

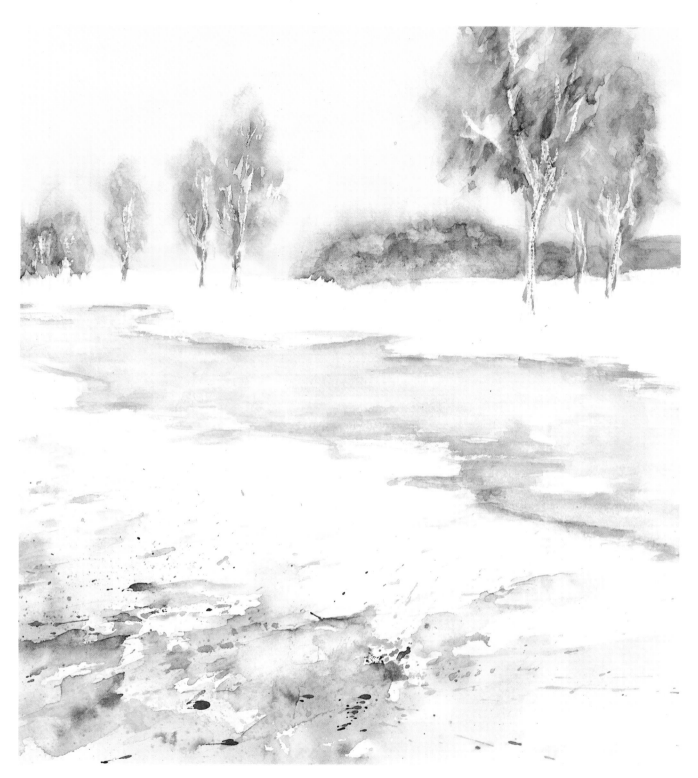

In this example, the paper has dried further. In some areas, the paint remains where I put it; in others, it still runs a little. So that I can work quickly and spontaneously, I use the tip of a sharpened candle to mask off the areas where I want the tree limbs and trunks to be. When I paint over the wax, it leaves delicate lines. I could also apply wax before soaking the paper, but often this approach doesn't leave enough room for spontaneity. Moreover, the results often seem too harsh in comparison to the overall mood of the painting.

The painting is finished when the paper is completely dry. I then lay it between two sheets of paper and put it under a pile of books to press it flat.

Painting a Mediterranean Landscape

with Karlheinz Gross

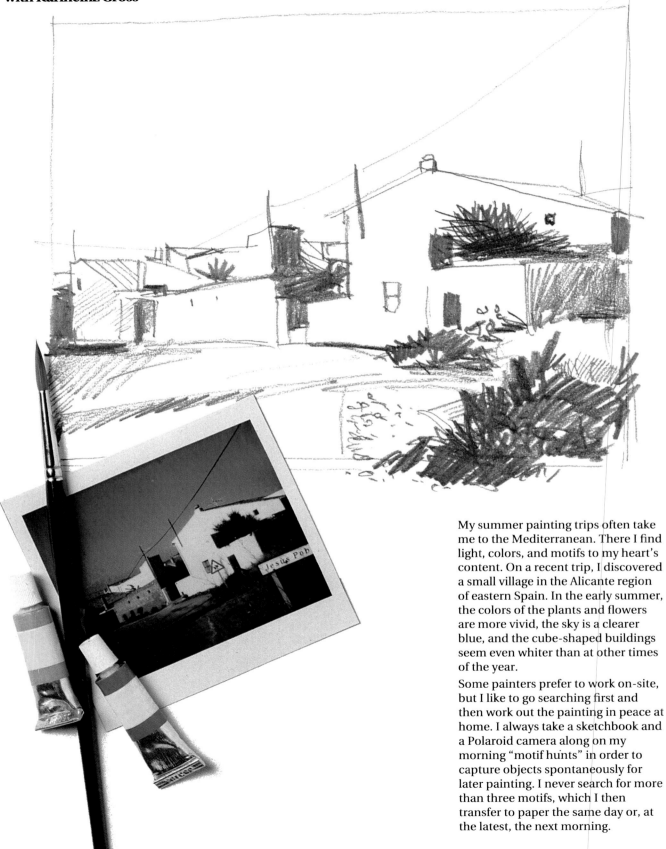

My summer painting trips often take me to the Mediterranean. There I find light, colors, and motifs to my heart's content. On a recent trip, I discovered a small village in the Alicante region of eastern Spain. In the early summer, the colors of the plants and flowers are more vivid, the sky is a clearer blue, and the cube-shaped buildings seem even whiter than at other times of the year.

Some painters prefer to work on-site, but I like to go searching first and then work out the painting in peace at home. I always take a sketchbook and a Polaroid camera along on my morning "motif hunts" in order to capture objects spontaneously for later painting. I never search for more than three motifs, which I then transfer to paper the same day or, at the latest, the next morning.

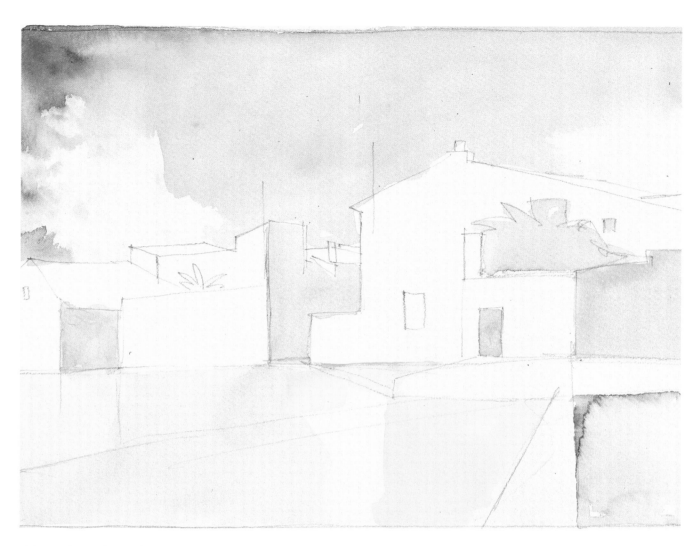

This timeliness keeps the impressions fresh, and I'm still enthusiastic about most of what I've seen. Of course, sometimes when I'm painting a motif, I find that it just doesn't interest me anymore. Because I have several motifs, however, I can vary my subject—for example, I can take a group of plants from one photo and transfer it to another motif.

This is essentially what I've done in preparing to re-create the Spanish village in watercolors. As you can see, there are some road signs in the photograph at the right, which is the basis for my motif. These, along with the cluttered foreground, bother me. I also think the gray asphalt should be lighter. The agave plants from another photo go much better with the snow-white buildings, so I add the plants in my sketch, cross-hatching them with a soft pencil. I also indicate the thick overhead wires in the sketch, but I will leave them out in the final painting.

While I'm transferring the motif—that is, before I even apply the first paints—I decide which areas I want to leave white. The decision is obvious in this motif: the sunlit building walls must remain white, and the street should be light as well.

I begin with very thin, light paint so I can build on it later. Because it's difficult to cover up the paints, watercolorists shouldn't begin with dark hues.

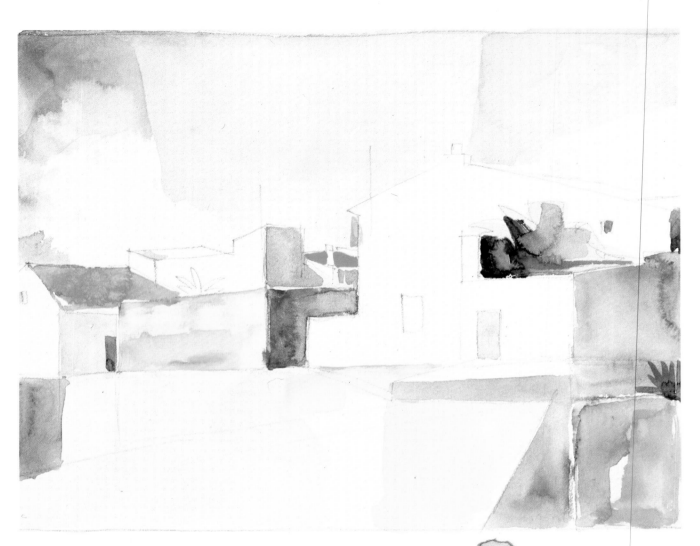

I use very thin cerulean blue for the radiant sky. I apply the shadows with ultramarine blue, not with gray, which could dim the radiance; the blue preserves the liveliness of the light. The yellow of the buildings is repeated lightly in the sky, the blue of the sky in the buildings. This color repetition unifies the painting.

Always try to keep an eye on the entire painting, and worry about details last. Otherwise, it's very easy to waste your efforts. Feel free to step back from your painting and look at the overall impression before you continue to paint.

I always keep a piece of paper handy that is the same as the surface I'm painting on. This "scratch paper" allows me to try out different mixtures and effects before I put them in my painting. To the right you can see an example of this experimentation.

I try these experiments while painting: violet in thick coats, thin coats, and glazes. Such experiments can help prevent unwanted effects in the painting itself, and they can also inspire you to try techniques you haven't thought of before.

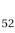

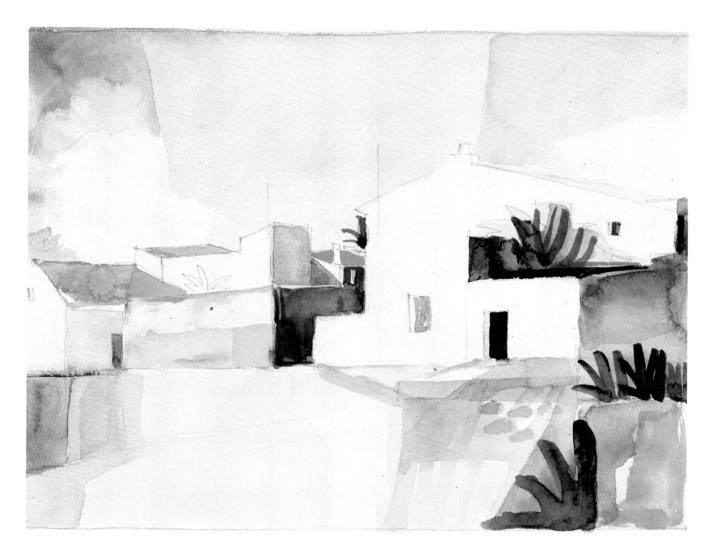

I use a mixture of yellow ochre and cadmium yellow for some of the roofs—but I don't use it for all of them because such a color scheme would be boring.

When using color, always follow your intuition and not necessarily what you see. The colors should express the mood you feel when you look at the motif. The painting shouldn't be a photographic reproduction of reality—cameras can do that job better.

When you're painting the light—in this case, the sparkling colors of the Mediterranean—you are not able to paint over areas very often: the watercolors lose their brilliance and become muddy with frequent overpainting. It's better to begin again because it's difficult to fix mistakes in a watercolor painting. For this reason, I always have a few tissues handy in case I apply paint that is too intense or not quite what I want. I also use a blow dryer, which helps me work more spontaneously because I can dry the paints quickly.

In this example, you can see the emphasis on the buildings' core shadows, which give the painting depth and the houses three-dimensionality. The plants also have more definite shape. Ochre used as an earth color, umber used as shadow, and Hooker's green mixed with different yellows and blues give the plants the right luminosity.

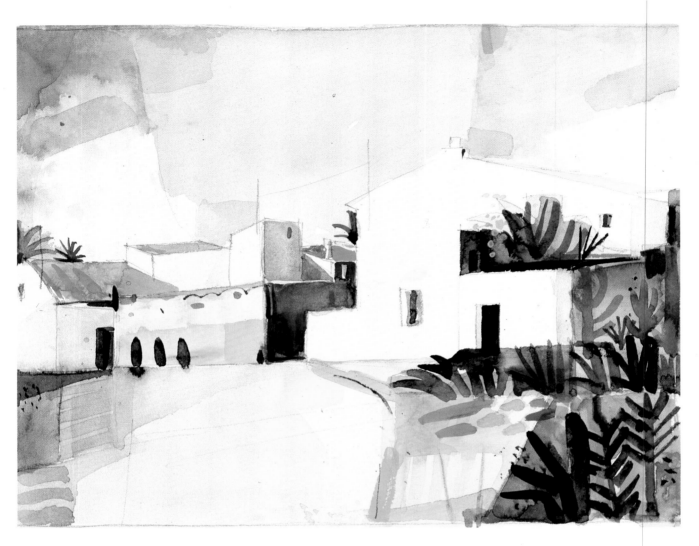

The details, small corrections here and there, and minor changes are added last. These can all be done with wet paint on a dry background. In this example, you can see that the plants have been given more form and the buildings and windows more contours.

In the south, I recommend painting in the early morning or late afternoon. For one thing, the temperature is more pleasant at those times of day than at others, and for another, the shadows are longer and provide more contrasts. Whether you're painting indoors or out, always muster up the courage to try new shapes and colors, and never be afraid to omit objects that bother you.

On trips, you have the opportunity to lose yourself. You're free from everyday cares, and you can simply paint. You're free to take chances and make mistakes. Painted memories of your trip can make it special because paintings, more so than photos,

contain personal and individual impressions. When you return home, it really doesn't matter whether you leave street signs or telephone poles out of a scene—it isn't necessary to remember them!

I fit the colors of the plants in the shadows to the colors of the shadows themselves. I apply cerulean blue and ultramarine blue to the wet background, and I get the shimmer of yellow by applying "dry" yellow.

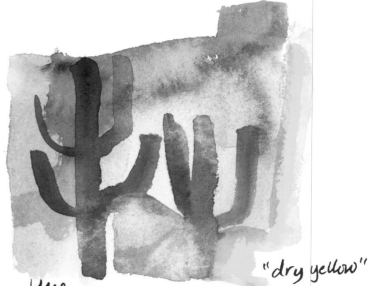

cerulean blue
and ultramarine blue

"dry yellow"

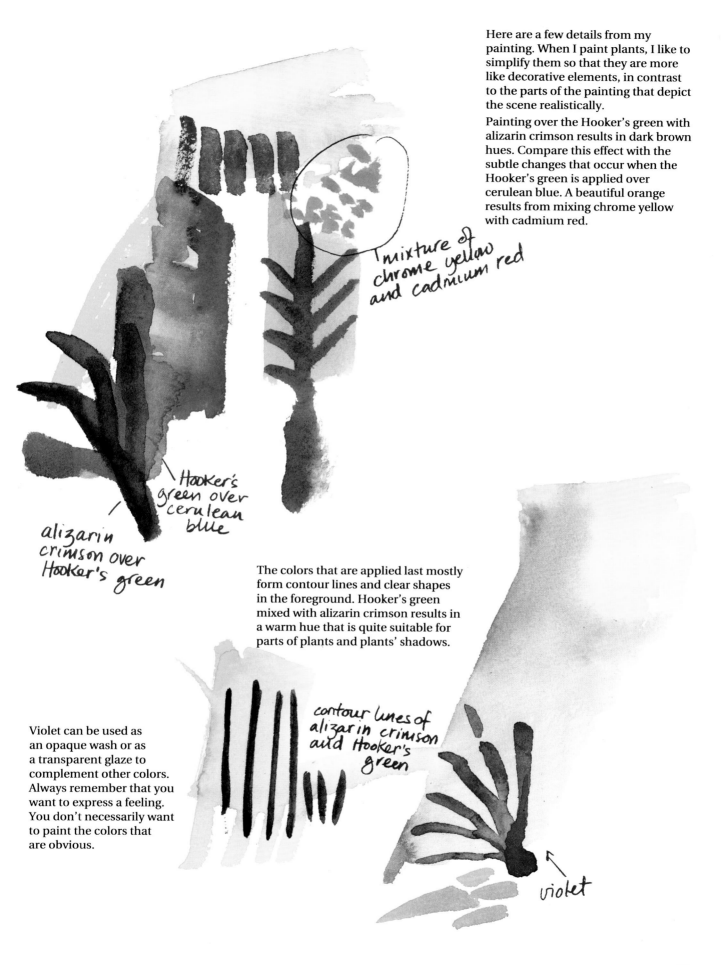

Here are a few details from my painting. When I paint plants, I like to simplify them so that they are more like decorative elements, in contrast to the parts of the painting that depict the scene realistically.

Painting over the Hooker's green with alizarin crimson results in dark brown hues. Compare this effect with the subtle changes that occur when the Hooker's green is applied over cerulean blue. A beautiful orange results from mixing chrome yellow with cadmium red.

mixture of chrome yellow and cadmium red

Hooker's green over cerulean blue

alizarin crimson over Hooker's green

The colors that are applied last mostly form contour lines and clear shapes in the foreground. Hooker's green mixed with alizarin crimson results in a warm hue that is quite suitable for parts of plants and plants' shadows.

Violet can be used as an opaque wash or as a transparent glaze to complement other colors. Always remember that you want to express a feeling. You don't necessarily want to paint the colors that are obvious.

contour lines of alizarin crimson and Hooker's green

violet

55

Experiments

Above all, painting should be fun. Don't stifle your creativity with unrealistic expectations. Did you forget to leave a white area in your painting? Then create the area with opaque white. What if the color underneath mixes with the white? Perhaps you'll discover a pleasing effect!

Cut up your painting and reassemble it as you would a puzzle—perhaps producing a different picture. Paste something over it, or turn it upside down. An artist once left a painting lying in the rain and was never able to achieve the same effect again. That picture is hanging in the artist's living room. So you see, everything is allowed in watercolor, as long as you like the result.

Pen and Colored Ink

Ink lines run differently, depending on the wetness of the paper. An effective drawing can result from the interplay of ink and watercolor.

Watercolor Crayons

Watercolor crayons are also called aquarelle pencils, but you can simply use colored pencils that are water-soluble. Watercolor crayons are easy to use. Just draw with them, and then go over the lines with a wet brush to spread the colors. Some artists like to use them in a painting that is still wet and blur some parts of the lines. You can add highlights or hard edges later.

Above: Watercolor crayons run when you go over them with water.

Right: A combination of watercolor and watercolor crayon

56

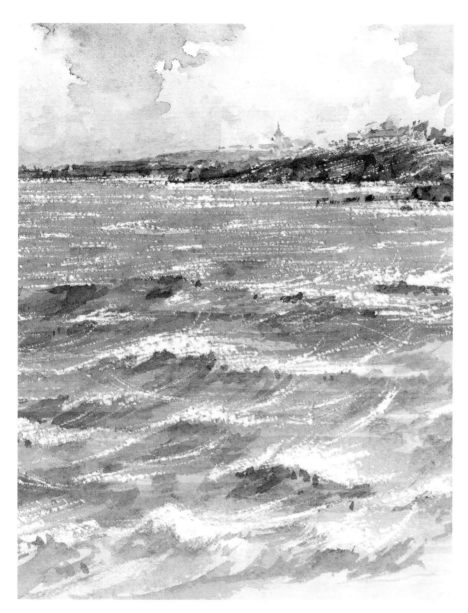

Look closely at this painting by Laurie Sartin. How do you think he created the white foam on the waves? Your eyes aren't playing tricks on you: he scratched it in.

If you scratch a wet painting, you can create white lines; if you paint over these lines, they fill with paint and become darker. The best tool for scratching paintings is a sharp letter opener, which allows you to control the width of the marks. If you hold it flat, for example, the scratches are wide. Of course, you can also use a needle or scissors, but these tools tend to make scratches that are always the same.

In this painting, Sartin scratched out rather large areas in the foreground where the caps of the waves are most defined, whereas in the background he scratched in thin lines because the caps are less obvious. When the painting was almost finished, he emphasized the shadows with dark hues to give the water more movement.

Below you can see this technique more clearly. The paints are applied around areas that will remain white. Then the artist scratches into the paint to blend the white into the colors.

This is a mixture of Prussian blue, Payne's gray, and a touch of burnt umber.

A Few Tips

You can experiment with the effects of tonal values without much effort, as the example below demonstrates. Some artists like to sketch their motifs with water-soluble felt markers, then go over the sketches with water or thinned ink. The marker lines become blue as they fade, the thinned ink brown. This mixture has a satisfying effect, and you can use it to determine where to put tonal values in your composition.

To gain courage to work with unusual color schemes, experiment with water-soluble felt markers or watercolor crayons. Why not have a red tree and a yellow meadow? Try it sometime!

Little sketches like the two below are often appealing, and it would be a shame to throw them away. Collect a few of them, and put them all together on one page. You can make one big composition from many little ones.

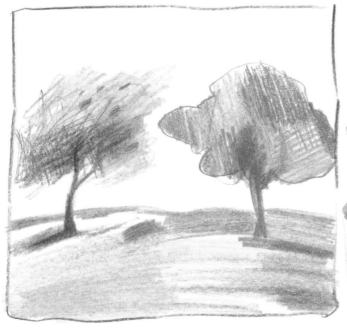

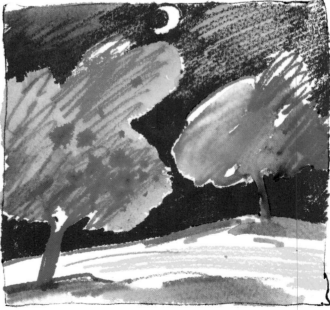

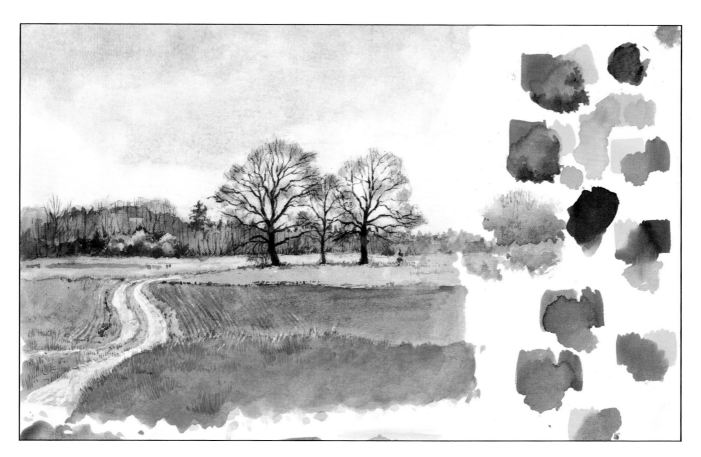

Although it's not a lot of trouble to paint outdoors with watercolors, you nevertheless need a place for your paints, palette, and container of water. Laurie Sartin leaves his palette at home and takes only a pad of large paper. He uses one part of the page for mixing paints and the other part for painting the picture (see the example above).

With this method, you can see immediately the way a mixture reacts on the paper and how it looks next to the other colors. You can also use part of the page to support your hand while painting small details. If you paint on the entire page, you may smear parts of the picture.

When Sartin has finished, he puts a mat around the painting to cover the area where he mixed the paints (see below left). Sartin painted this picture in the fall; imagining the way the same landscape would look in summer, he simply added a summer meadow and leaves (below right). Let yourself be inspired by your paintings, and try anything that pops into your head!

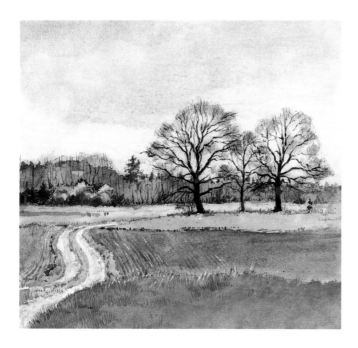

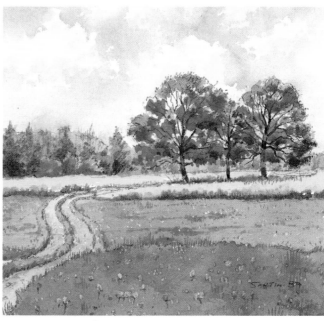

Motifs for Inspiration

Perhaps you know this feeling: you have a strong urge to paint, you get out your materials—and then you don't know what to paint. Perhaps the suggestions here will help you with this problem. The photo images can be transformed effectively into watercolor paintings. Of course, you can also paint landscapes from your imagination. Have you ever tried it? One artist always thinks of the same scene—a tree, a meadow, and mountains—in attempting to paint what the mind's eye sees. Although there's nothing wrong with repeating an imagined motif, people don't have the unlimited possibilities—the whole universe of different colors and moods—in their head. Photos like the ones on these pages can be an inspiration—but only an inspiration. You can take sections from them, change their size, or totally re-create them any way you like.

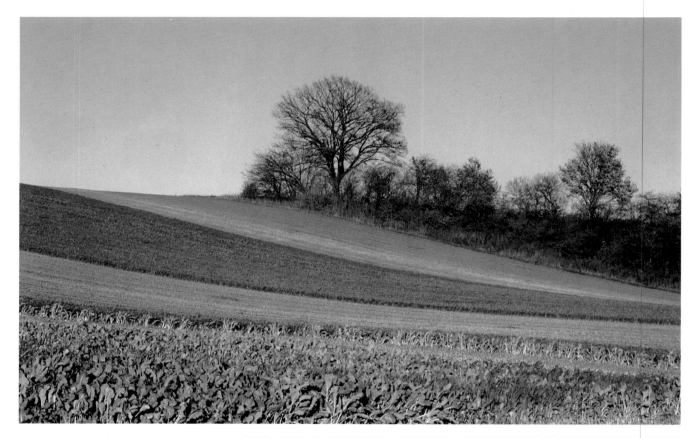

Take the tree and meadow as an example. In the photo above, the fine limbs of the tree provide an interesting contrast to the smooth fields. You could lay in the large areas of green wet-in-wet and the delicate limbs on a damp, and finally dry, background. Here the sky plays an insignificant role.

The picture at the right is quite different. The dramatic cloud formation dominates the composition. The textures of the grass and trees in the foreground are also important. While the sky really lets you go wild, the foreground requires more precise painting. The dark forest in the distance produces a convenient separation of sky and field.

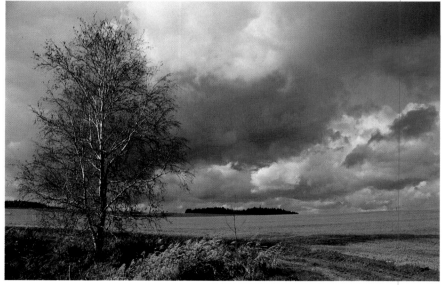

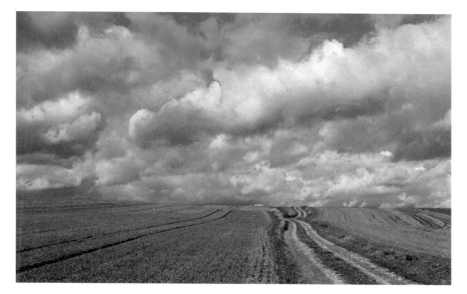

Even without a tree, this field is interesting. The horizon extends across the lower half of the painting, and the diagonal path off to the right creates tension. This is a wonderful motif for combining different techniques.

You could work wet-in-wet in the sky, leaving areas of white for the clouds and perhaps even lifting some off with a tissue or cloth. For the field, you could work with strokes that gradually become drier, or you could scratch out portions of the field and paint over them again.

To the right is a motif for practicing reflections that invites you to use many of the techniques discussed in this book. The floating leaves function as highlights, the sky is reflected in the water, and the fine blades of grass have the appearance of a glaze. If you like, you can also bring completely different colors into the painting; for example, you could add violet between the blades of grass and let it reflect in the water.

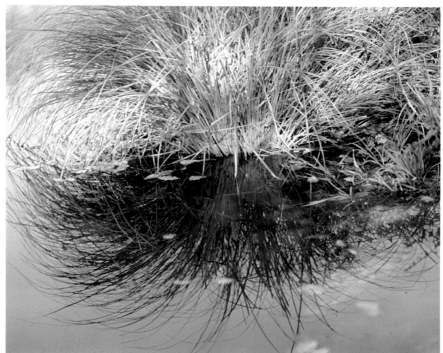

The photo to the left is a mono-chromatic motif that comes alive through its textures. In spite of the single color scheme, contrast is clearly apparent. Perhaps you'd like to concentrate on the different greens. Here also, an artist might imagine fine strokes or scratches, or even the use of a sharpened candle to make wax lines so that the paint will form beads. Be creative!

Glossary

cast shadow
A shadow created when an opaque object blocks a light source. The size and shape of the cast shadow are influenced by the position of the light source.

core shadow
The shadow found on an object. The core shadow is always lighter than the cast shadow and gives an object its shape and three-dimensionality.

Expressionism
An artistic movement of the early twentieth century that was a reaction against Impressionism. The Expressionists were more interested in the expression of the inner experiences of the artist than in the aesthetic enjoyment of art.

fresco
A technique of painting on wet plaster. The term comes from the Italian word for "fresh." *See also* **wet-in-wet.**

glaze
A thin, transparent layer of paint applied over dry paint. Because the glaze does not completely cover previous layers of paint, it is possible to achieve delicate mixtures and subtle nuances. Glazes are particularly suitable for painting in watercolor because of the transparency of the paints.

handmade paper
Paper that is made by hand rather than by machine. The best watercolor paper is handmade from linen rag, which is boiled, shredded, and beaten to a smooth pulp. The pulp is run over a fine screen, dried, and pressed. This technique is still practiced, but the paper is very expensive.

Impressionism
An artistic movement that originated in France in the mid-1860s. The name comes from a painting by Monet entitled *Impression—Sunrise*. The Impressionists were particularly interested in light and color, and they held that the artist is led by visual impressions and attempts to re-create the mood of a subject. The favorite motifs of the Impressionists were bright landscapes and animated scenes from daily life.

liquid frisket
A kind of masking fluid that can be rubbed off when dry. In watercolor, it is especially useful for masking off areas of white.

monochrome
A painting done in different shades of a single color. Since approximately 1955, monochrome has developed as a painting style in contemporary art.

negative space
Space that forms between objects in a motif or between the motif and the frame.

plasticity
The effect of three-dimensionality. Just as the sculptor can model a three-dimensional figure, the painter can use techniques to achieve the illusion of space. *See also* **core shadow**.

tonal value
The degree of darkness or lightness in a color, measured on a scale of gradations between black and white.

transparency
The quality of watercolor that allows it to modify the color over which it is applied without completely covering it. *See also* **glaze.**

vanishing lines
Parallel lines that lead from the viewer into the distance in a picture. They appear to come closer to one another until they converge at a single point—the vanishing point. The direction of the lines depends on the viewer's position relative to the object.

wash
An application of diluted paint that covers large areas of paper. A wash is laid from top to bottom on wet paper with a thick brush or a sponge.

wet-in-wet
A technique of working with fresh paint on a wet surface. Working wet-in-wet allows the artist to achieve soft blends and delicate contours.

wet-on-dry
A technique of applying fresh paint to a dry surface. Working wet-on-dry results in clear shapes and hard edges.

Index

Credits

Paul Cézanne, *Château at Médan* (page 7): Kunsthaus Zürich, © 1991 by Kunsthaus Zürich

John Sell Cotman, *Trees at Harrow* (page 6): The Whitworth Art Gallery, University of Manchester

John Middleton, *Alby, Norfolk* (page 7): Norfolk Museums Service (Norwich Castle Museum)

Emil Nolde, *Flood* (page 7): © Nolde-Stiftung Seebüll

J.M.W. Turner, *The Burning of the Houses of Parliament* (page 6): Tate Gallery Publications, London

Maurice de Vlaminck, *Landscape* (page 7): Graphische Sammlung der Staatsgalerie Stuttgart

Watercolors — Landscape
Recommended Readings

Edin, Rose. *Watercolor Workshop/1*. How To Series. Laguna Hills, California: Walter Foster Publishing. 1989. #HT213. ISBN: 0-929261-23-2.

Light, Duane R. *Watercolor*. Artist's Library Series. Laguna Hills, California: Walter Foster Publishing. 1984. #AL02. ISBN: 0-929261-04-6.

Peterson, Kolan. *Watercolors Step-by-Step*. How To Series. Laguna Hills, California: Walter Foster Publishing. 1989. #HT205. ISBN: 0-929261-47-X.

Powell, William F. *Watercolor & Acrylic Painting Materials*. Artist's Library Series. Laguna Hills, California: Walter Foster Publishing. 1990. #AL18. ISBN: 1-56010-060-5.